DENALI
REFLECTIONS OF A NATURALIST

TEXT AND PHOTOGRAPHY BY

KENNAN WARD

NorthWord Press

Minnetonka, Minnesota

DEDICATION

This book is dedicated to the people who still believe in true,
natural-history photography and real wildlife, in unmanipulated and authentic landscapes.
These are Nature's stories, the way wilderness presents them to us,
and the way we would like to continue to learn about the natural world.

IN MEMORY OF

Helen Rhode . 1919–1994

Michio Hoshino . 1952–1996

Kenneth (Chip) Houseman 1963–1998

Helen Gromme . 1970–1998

Text and Photography © Kennan Ward, 2000
Except the following photography by Karen Ward: pgs. 15, 36, 65, and jacket portrait.

Book design by Russell S. Kuepper

NorthWord Press
5900 Green Oak Drive
Minnetonka, MN 55343
1-800-328-3895

All photos in this book adhere to "Truth in Photography" first established by Kennan Ward in 1994. All animals are wild and unmanipulated by feeding, calling, or any other behavior-altering means. No landscape photos are computer-manipulated, altered, or enhanced. We believe in true natural-history photography.

Library of Congress Cataloging-in-Publication Data
 Ward, Kennan.
 Denali : reflections of a naturalist / Kennan Ward.
 p. cm.
 ISBN 1-55971-716-5 (hardcover)
 1. Natural history—Alaska—Denali National Park and Preserve.
 I. Title.
 QH105.W367 1999
 508.798'3—dc21 99-26465

Printed in Singapore

ACKNOWLEDGMENTS

Karen Ward
A special thanks for every step in this book since 1985,
our first visit to Denali together.

Copyediting
Tom Bentley

For inspiration with the text
Candace Ward, Lindsay Kircher, Emily Means, John Hectal, Shane Moore,
Claudia (Jenny) Harris, and Charlie Loeb

For lasting friendships on the road
Walter and Candace Ward, Robert and Carolyn Buchanan, Shane and Lybby Moore,
Lewis and Janice Schnaper, Joel and Louisa Bennett, and Michael Mauro

For encouragement and confidence
Thomas and Elizabeth Ward
Larry and Barbara Frear

A special thank you to
The staff at WildLight Press, and Kennan Ward Photography for everyday help, assistance, and endurance.
Especially: Emily Means, Chuck Holmes, and Leigh Ann Maze

To the Denali, Alaska Natural History Association for support of this project
Especially: Claudia (Jenny) Harris, Charlie Loeb, and the entire staff in Denali

To all the people at Creative Publishing international / NorthWord Press
Especially: Iain Macfarlane and Barbara Harold. Thank you.

Karen and I would personally like to thank the many helping hands from the staff of Denali National Park.
To all the rangers, the next generation, and all of the friends we have met in the two decades working in the park: you have our gratitude.

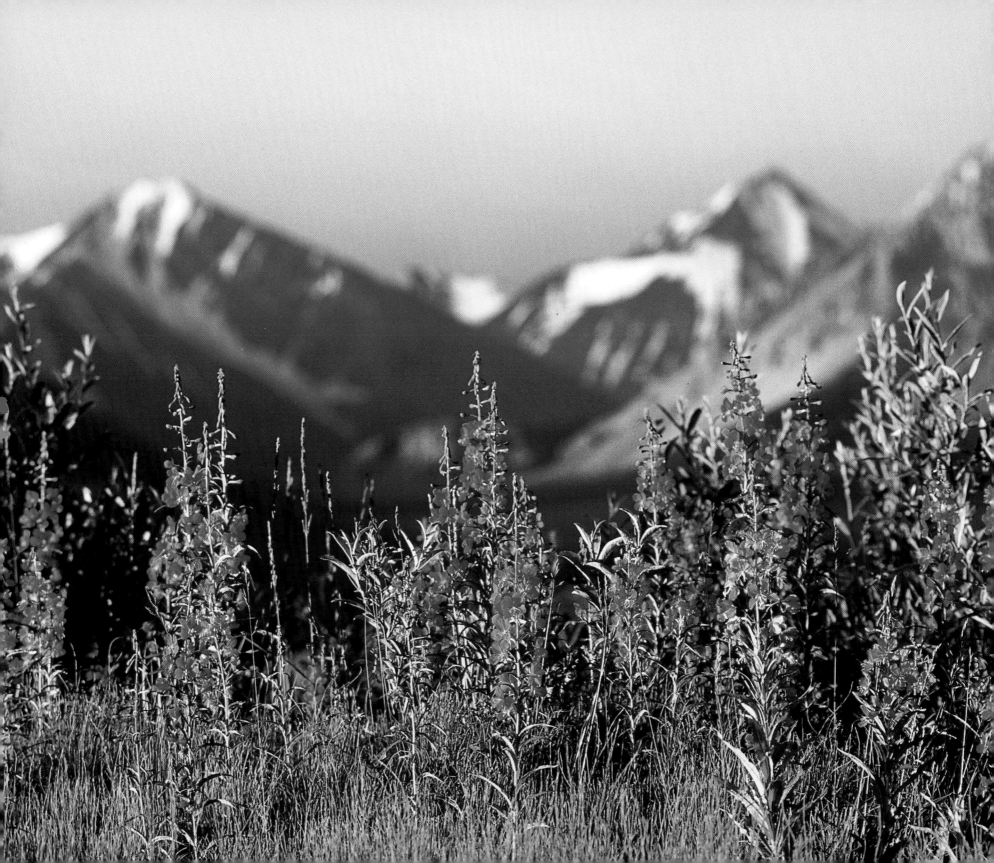

Table of Contents

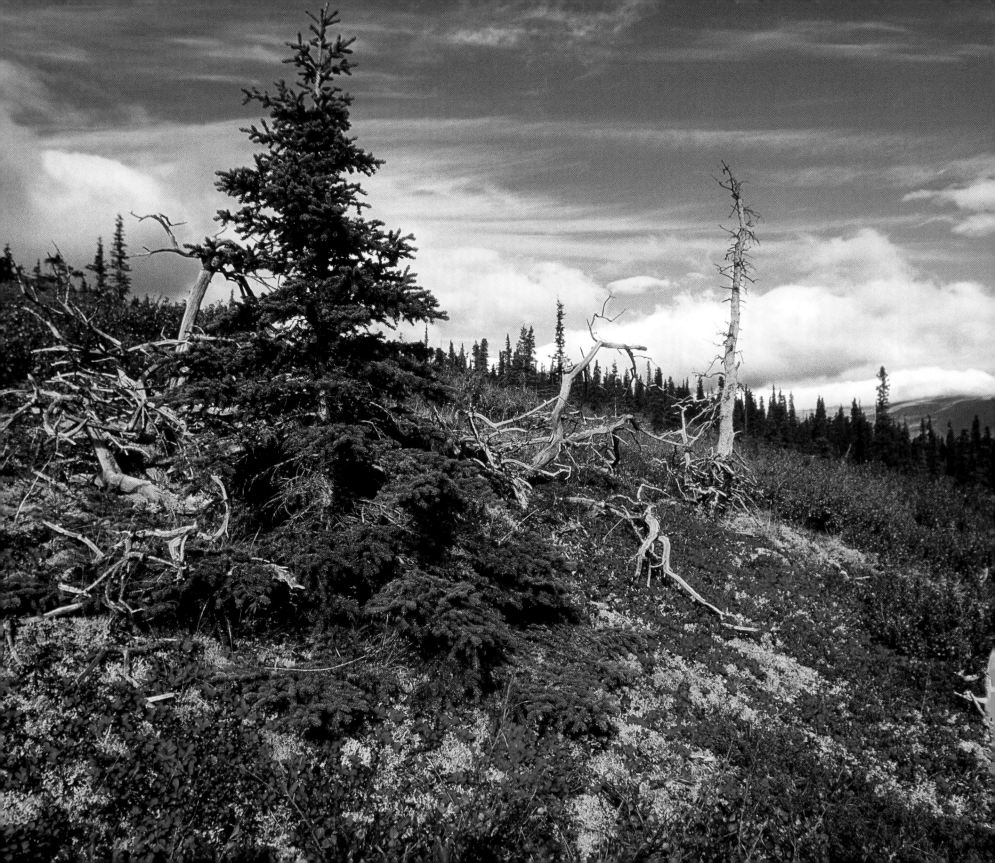

▲▲▲
PREFACE

We find comfort in broad, sweeping terrain, a kind of ancestral
awareness imparted from the landscape.

Whatever the combination of instinct, intuition, and learning, the processing of visual information increased our ability to hunt efficiently and secure ourselves from unpleasant surprises. It might have been this unusual sense of comfort that invited our curious ancestors long ago to venture out and add personal experience to this visual awareness.

When I look out onto the landscape of the Alaska Range, I feel that visual solace, as well as that ancestral curiosity. Here is deep sight on a broad path, a path as great as the imagination can reach. Along this range, the horizon builds from the foreground of open fields of tundra to the tallest peak in North America, the massive Mount McKinley—Denali—at 20,320 feet. From Anchorage at sea level you can view Denali, 250 miles to the north, with recognizable detail on the rare clear day. From Fairbanks, looking south 150 miles, another clear view of the mountain highlights the north face of the Alaska Range. It is an extended view that directly feeds into my own ancestral sense of well-being.

The landscape of the Alaska Range inspires an uncommon bond, an affinity, in humans. I have returned here again and again over the past twenty-some years to drink in the vastness of its wilderness, the remarkable variety of flora and fauna, and a certain elemental force that's almost indescribable. The land itself is almost like an entity, powerful and without peer. This book is an attempt to bear witness to that force.

The photographs in this work touch on all aspects of my years of wandering this vast park, confirming and expressing that visual sustenance I alluded to. They cover its exhilarations, dangers, and wonders, but it's hard to say if anything can capture its essence. It's simply too vast, too rich, too boundless.

In 1980, there was overwhelming support to change Mount McKinley's name back to its original Athabascan name, meaning The Great One or The High One. Throughout the book, I use the names McKinley and Denali synonymously, both to refer to the mountain itself and the surrounding park.

My hopes are that with pictures, words, and experiences, I might begin to describe an unparalleled landscape that my wife Karen and I dream of, and hope to return to, as long as we live. It is a sacred place.

A typical view of Alaskan tundra—a spruce tree surrounded by bare snags, lichens, and moss.

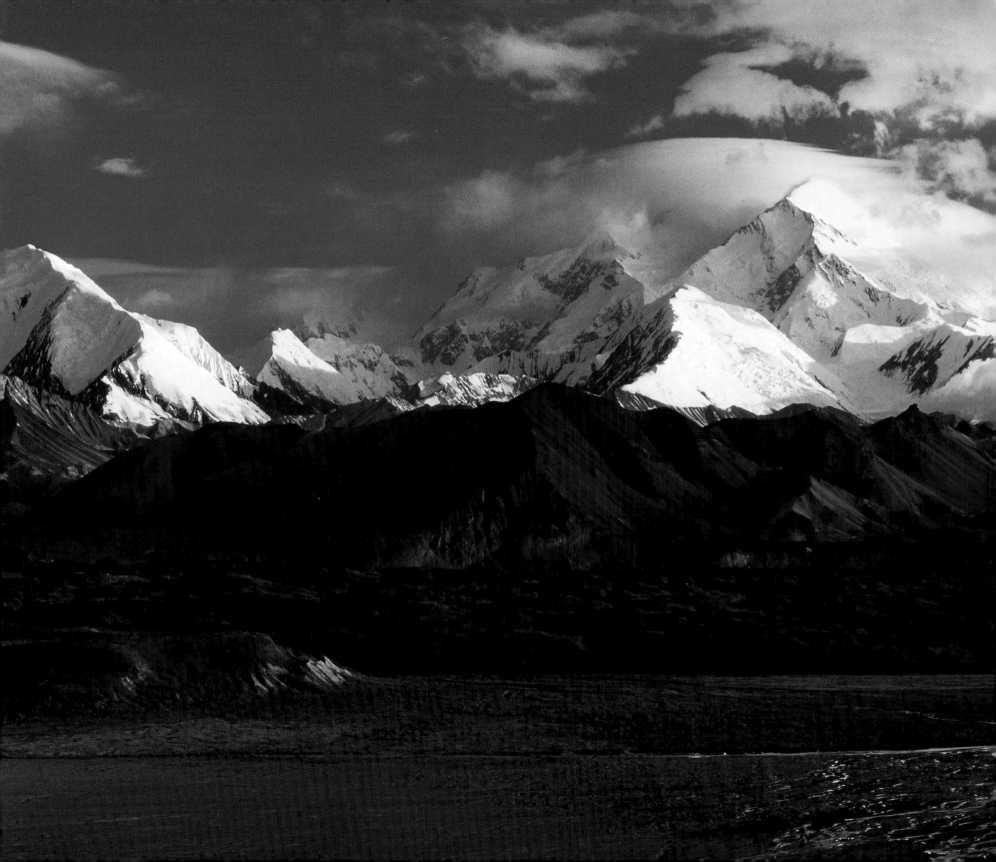

▲▲▲
INTRODUCTION

Like other national parks, Denali National Park and Preserve represents a unique piece
of the natural and cultural heritage of the United States and the world.

But Denali is unique even by the standards of our national parks—guided by an evolving, ambitious vision that has
been progressively revealed from its conception to the present day by exceptional individuals who were inspired by
the park's wildlife and wilderness.

The park's unique history began in the first decade of the twentieth century, when a renowned hunter and naturalist named Charles Sheldon visited the Mount McKinley region, accompanied by Harry Karstens, a hardy sourdough guide with great experience in the wilds of Interior Alaska. Sheldon had traveled throughout North America, hunting and studying wild sheep, and had finally come to pursue the most isolated of all North American sheep species, the white Dall sheep, found only in the far north. But he found more than sheep. First on an expedition in 1906, and then for an entire year from 1907 to 1908, Sheldon found a landscape he loved. From a cabin on the Toklat River, he explored the mountains and valleys below the great peak, which had only recently been named Mount McKinley, studying the extraordinary wildlife populations of the region and gaining insight to the land. Inspired by the unusual concentrations of large animals but worried about the damage market hunters were doing to caribou, sheep, and moose, he dreamed of establishing a national park to protect the creatures of this spectacularly scenic place.

It was remarkable foresight. In 1908, the Interior of Alaska had barely been explored. Although native Athabascan Indians had inhabited the area for thousands of years, only six years previously had the first expedition of European Americans passed through the valleys that now comprise the heart of the park. Only three years earlier had the first settlers come to the Kantishna Hills during a brief gold rush. The National Park Service would not exist for eight more years, and only a handful of national parks existed, most created to protect scenic landscapes like the geysers of Yellowstone and the granite cliffs and waterfalls of Yosemite. While Sheldon saw the great beauty of the Denali landscape, his focus was the protection of the wildlife. A national park? For wildlife? In the middle of nowhere?

In 1917 Mount McKinley National Park became the first new national park created after the establishment of the National Park Service in 1916.
Charles Sheldon, Harry Karstens, and Adolph Murie contributed their individual time and passion as explorers, workers, and biologists toward making the park a national treasure.

Sheldon persisted in his vision, and he succeeded in making it real. In 1917, Mount McKinley National Park became the first new national park created after the establishment of the National Park Service in 1916. Although named for the mountain, protection of wildlife was the primary purpose of the park. Sheldon argued for the use of the native name for the mountain, Denali, to identify the national park, but he was not successful in this part of his dream since Mount McKinley had become well established as the moniker for the highest peak in North America.

On paper the park existed, but it needed staff. Sheldon knew that caring for the new park required a ranger capable of surviving patrols in the harsh climate of Interior Alaska. It required someone capable of building a park infrastructure in the wilderness. It required someone with the impeccable credentials of an Alaskan sourdough, who could convince local hunters to find their game elsewhere. The park needed Harry Karstens, Sheldon's guide and the renowned "70-mile Kid," who had hauled supplies for miners across the Interior, serviced Alaska mail routes by dog team through the dead of winter, and in 1913 jointly led with Hudson Stuck the first expedition to reach the true summit of

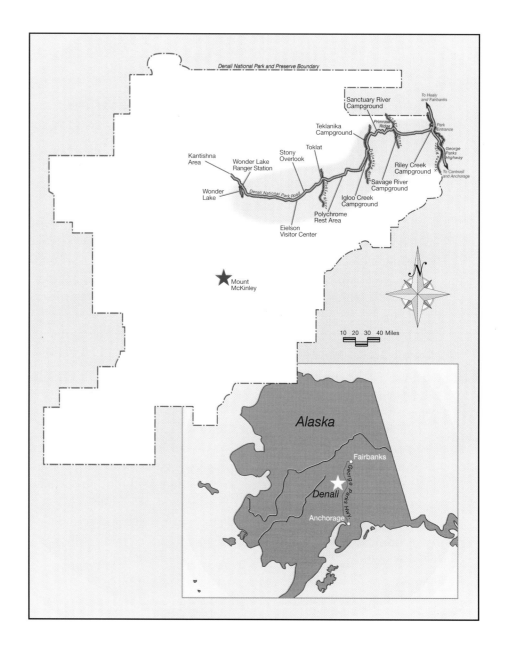

Mount McKinley. In 1921, four years after the park's founding, Karstens arrived to begin work as Mount McKinley National Park's first ranger.

Karstens successfully carried out Sheldon's vision for the park. He stopped the market hunting inside park boundaries with a ranger force that patrolled the park by dog sled. He met the first park visitors who arrived on the newly finished Alaska Railroad in 1923. He constructed a park headquarters and pioneered a road destined to reach 90 miles to Wonder Lake and the Kantishna Hills. He started the first concession facilities to provide overnight accommodations at Savage River. Although his rough sourdough style eventually led to his downfall as a federal employee, Karstens set the stage for all that followed. The superintendents who succeeded Karstens completed the major projects he began, finishing the park road to Kantishna in 1938 and in 1939 building the only hotel ever constructed in the park. World War II stopped other development plans as the park temporarily became a military recreation center for troops stationed in Alaska.

During the war, the vision of the park continued to unfold through the work and thought of a biologist, Adolph Murie. Murie was brought to Mount McKinley National Park in 1939 to resolve a major controversy over wolf control. After years of exterminating wolves in national parks elsewhere, the National Park Service was feeling its way toward a policy that did not favor prey species over predators, making wolf protection equal in importance to protecting moose, caribou, or sheep. But with severe winters and a resultant steep decline of Dall sheep in Mount McKinley, the eastern hunting elite joined local Alaskans in lobbying for control of the park's wolves. Murie brought a scientific perspective to the issue, as he researched his landmark work, *The Wolves of Mount McKinley* (1944).

Murie's research findings bolstered the position of the National Park Service, indicating that wolves primarily preyed on sheep that were particularly weak, old, or sick, incidentally helping to strengthen the herd overall. Despite the positive findings, the politics of the era still pressured the Park Service into conducting limited wolf control into the 1950s, but the balance had shifted and a more ecological perspective took hold. Once discontinued, wolf control was gone forever. Murie became the park's resident biologist, and his ongoing wildlife studies also indicated that the park—although enormous—was not large enough to protect the wildlife from threats outside the boundaries, and he suggested that expansion to the north and west would be important for the long-term integrity of the park's wildlife populations. Murie extended Sheldon's vision, recognizing that preserving wildlife meant preserving an entire ecosystem and ecological processes as well.

Adolph Murie was a visionary not only in his advocacy of ecological management of the national park; he also passionately defended the park's wilderness character. In the 1950s, the National Park Service proposed many new developments in Mount McKinley National Park as part of the nationwide Mission 66 program. Plans included a

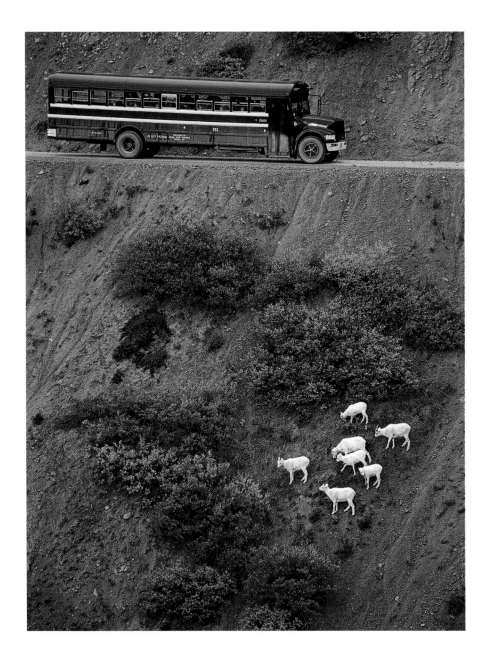

hotel at Wonder Lake, a snack shop at Polychrome, the widening and paving of the park road, the placement of interpretive signs along the road corridor, a visitor center above the Thorofare River, and many other developments.

Murie recognized that the proposed developments would forever alter the landscape he had come to love. With other conservationists, he adamantly insisted that the park's "wilderness spirit" was a unique and valuable part of the place, which would be devastated by extensive development along the park road. Eielson Visitor Center opened in 1960, but the hotel at Wonder Lake was never built, and the road is maintained in its primitive, wilderness condition. Rarely is history made by people who insist on not making changes, but Murie and the other defenders of the park's wilderness landscape were successful in shaping a vision unique to this park, one in which visitors would be immersed in a magical, undeveloped natural landscape with its wilderness character intact.

New challenges were ahead. Transportation access has always figured heavily in the story of the park. The railroad brought the park's visitors in 1923. In 1957,

A group of Dall sheep graze on a steep hillside. The bus serves as a shuttle within the park providing access and convenience to visitors while preserving the park's wildlife.

the primitive Denali Highway was completed from Paxson and a trickle of visitors began to arrive by automobile. In 1972, however, conditions changed dramatically with the completion of the George Parks Highway linking Fairbanks and Anchorage, providing the first paved, all-weather access to the park entrance. The park was now faced with the long-term potential of needing to accommodate hoards of private automobiles on the park road, which had been so carefully maintained to preserve its wilderness character and wildlife-viewing opportunities.

In the same spirit which had guided the park since its founding, the National Park Service pursued a unique solution. Instead of developing new roads or improving the existing one, park managers expanded the existing bus transportation system. Visitors would be required to leave their cars behind at the entrance and climb aboard the park's shuttle buses or the concessionaire's tour buses. Mount McKinley National Park might be in one of the most isolated parts of the United States, but it would be the first national park to embrace mass transit as the primary means for experiencing the park, and for preserving the wildlife and wilderness values of this unique place.

The year 1980 saw the completion of Adolph Murie's vision for the park. With the passage of the Alaska National Interest Lands Conservation Act, the United States Congress tripled the park's size from two million acres to six million acres. For the first time, the park came

to include the entire massif of Mount McKinley, as well as the enormous glaciers which stretch out from the south side of the Alaska Range. More important, the park boundaries were extended to the north and west to incorporate virtually the entire range of the Denali Caribou Herd. The park thus became one of the few protected areas in the world to encompass an intact, naturally functioning ecosystem. Although he passed away in the 1930s, Sheldon's vision was also completed: the enlarged park was renamed, becoming Denali National Park and Preserve.

The vision of Denali is under constant pressure from interests bent on remaking the park into something more ordinary, segmenting the vast wildlife habitat and wilderness with roads, cars, signs, hotels, and parking lots. But over time, valiant defenders have always appeared to fight for the integrity of the park, to carry the vision to the next generation, and to reveal the next dream. No wonder—the power of the landscape itself sustains the vision: the expanses of tundra, the sudden uplift of sharp mountains, the towering presence of the mountain called Denali, and the wildlife that roams across the mountains and valleys in this vast northern wilderness. Visions come easily in places like Denali, as does the strength to make the dreams come true.

Charlie Loeb, August 1999
Denali National Park

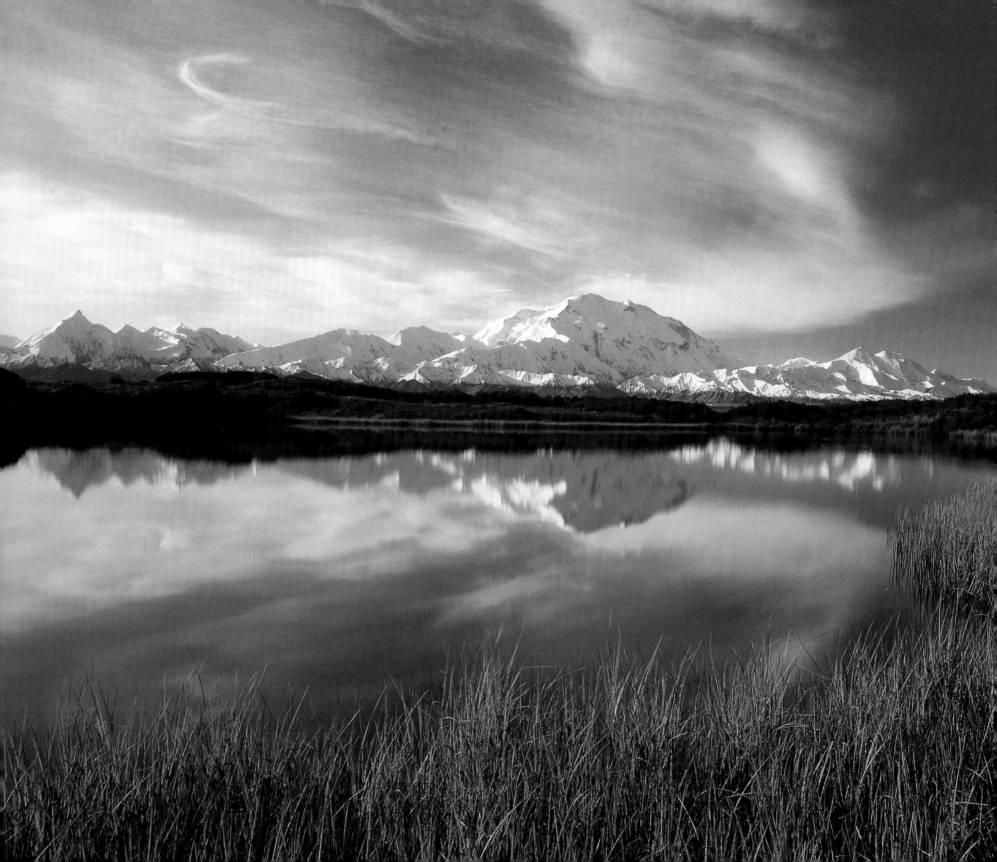

Chapter One

CHAMPIONS

The deeper we explore our interests in life, the more likely that we will find
a paradigm, some kind of standard of excellence or achievement.

The baseball fan might look no further than Mark McGuire's record-setting season of seventy home runs or David Wells' pitching of a perfect game. Hearing the Rolling Stones on the radio with another smash hit prompts one to wonder how long they can continue their creativity, and what might possibly drive them, after some thirty years as a top rock group.

When someone stands out in your chosen professional field, you might find yourself the victim of competitive feelings or jealousy. These standard-bearers, these paradigms, have achieved goals beyond the ordinary, often with the recognition that accompanies that accomplishment. These individuals possess a special factor or quality that sets them apart. They are champions.

This notion of "champion" shouldn't be restricted to humans. As you'll see, it is an apt designation for people, animals, and places that carry heavy emotional weight; things that bring influence and meaning to your own endeavors. Just as Charlie Loeb's Introduction referred to those towering figures of Sheldon, Karstens, and Murie, we all have champions of our own. And the most important one of mine is probably Denali itself.

LEFT: The Alaska Range, with the majestic snow-capped Denali mountain in the center, is reflected in Wonder Lake in the heart of Denali National Park.

ABOVE: My favorite landscape: Denali mountain leading into rolling hills and kettle ponds.

As a rookie ranger in the early 1970s, I often reflected on the various rangers of yesteryear. One was Steven Mather, the "father" of the forest rangers during the Teddy Roosevelt era. Around the campfire, I heard tales of modern-day mentors, the search-and-rescue rangers of current legend. Sometimes I wondered if some of these heroes and their heroics could be real. These tales made my daily work activities seem very ordinary.

Not only do rangers seek champion rangers to emulate, but they also yearn for experiences in champion parks. The merits of the classics were always debated—Yosemite, Yellowstone, Grand Canyon, Mount Rainier, and others. However, the crowds of people at those parks were always considered a drawback by potential rangers. In the end, the debates always halted at the mention of Mount McKinley National Park in Alaska. That park sounded like a stride beyond—an authentic adventure!

Here was the largest park in the United States, and there were very few crowds, if any. In those days of the early 1970s, McKinley sometimes sounded too good to be true because few people had experienced the frontier state or knew about its beauty. To most people, Mount McKinley National Park was a snow-and-ice world too harsh to take seriously. The few who were familiar with the park knew different. They were awed by the diverse wildlife, including grizzly bears, wolves, caribou, Dall sheep, and moose, and by the tallest peak in North America. Talk of those wonders was all an ambitious rookie needed to hear

* ✳ *

I was a seasonal ranger, working for California State Parks in the winter while I went to college, then returning to work in the National Parks in the summer. I had been a serious student of photography, shooting medium-format film and concentrating on capturing images of people, with a yearning for new compositions. One of my first champion rangers was Tim Setnika, my childhood neighbor, who during his summer rangering at Mount McKinley had taken a nice photograph of a red fox published on the cover of *National Wildlife* magazine in 1968. I was convinced that Tim's luck had come from opportunity and the wild location. Tim's work inspired me to become a park ranger. To work in Alaska and photograph large mammals was my dream.

Mount McKinley is a champion National Park. Its towering mountain hosts two million acres of land, and few crowds. The landscape is stark and bold; in some areas it seems as unreal as the moon. In the years before I traveled there, I devoured the stories from anyone's back-country experience. Years before the opportunity developed, I realized that my unconscious life plans were already bound up with Alaska cord.

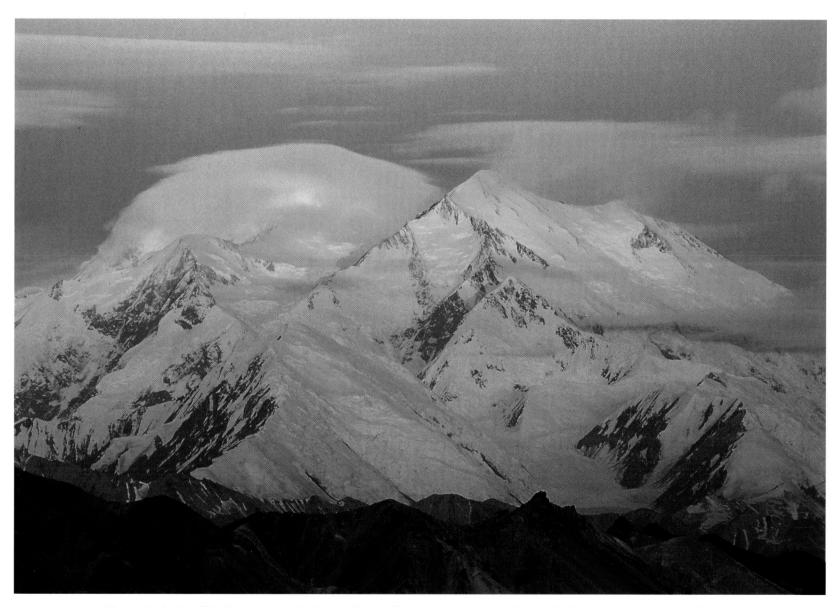

The towering heights of Denali reach into the clouds. South Peak actually creates its own weather, and is concealed by a whorl of clouds for most of the year. Spring and fall are the best times to catch a glimpse of the entire mountain, although rare clear days occur year-round.

I realized I would need to be more competitive in order to qualify as a ranger in Alaska. My supervisor ranger and mentor, Don Patton, advised me to get park ranger law-enforcement training to increase my "champion park" qualifications. Ranger Patton was tall with a full build—any person causing mischief in a park would have truly feared this man. In a posture reminiscent of Sergeant Preston of the Royal Canadian Mounted Police, Don captured my attention one day and gave me the career coaching I needed.

Big Basin Redwoods State Park was just the place to begin. It was a training park for new rangers. For one year, newly assigned park rangers were given varied duties, including visitor services, maintenance, natural-history interpretation, and formal training. The formal training included peace-officer courses at the Asilomar Training Academy.

At Big Basin, in addition to assisting visitors, we also built and maintained the miles of trails and trail camps along the picturesque Skyline-to-the-Sea Trail. I supervised ranger trainees for projects.

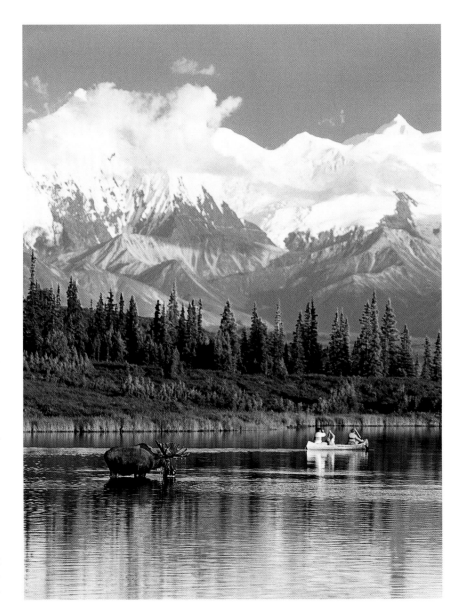

Denali is known for its abundant and active wildlife viewing. Canoeing, hiking, backpacking, bus tours, and river trips are all great ways to get a fascinating look at Alaska's wild creatures, such as this 1,400-pound bull moose in Wonder Lake.

Although I was their subordinate in rank, they respected my field experience. We had a lot of fun building foot bridges, trails, signs, and other projects. I enjoyed working with the trainees and we became close friends.

More and more, I thought I should become a full-time ranger. Competition for ranger jobs was fierce in the 1970s, as they became increasingly desirable. In order to qualify as a seasonal ranger for a major park, I needed more than a college education. It took four years of collective job training, work experience, and college education to compete for the high applicant rank needed for assignment as a seasonal park ranger in one of the major national parks. My first chance for upward mobility was acceptance to the law-enforcement training academy at Asilomar.

In April of 1977, I graduated from Asilomar Ranger Academy with the Basic Peace Officers Training (BPOT). I highlighted this unique qualification on my seasonal application for the National Park Service. I chose to apply to Mount McKinley, Yellowstone, and Grand Canyon, and I started receiving phone interviews in early April. The Grand Canyon, definitely a champion location, had a dream position for a back-country ranger. Yellowstone offered me a road-patrol position, based on my recent law-enforcement training at the Academy. Because I was self-supporting, I needed the highest possible pay level to save cash for my return to college. Both of these jobs had long seasons, and with school not starting until the beginning of October, I could bank more funds.

Then, Ranger Pete Ganache from Mount McKinley called one night to explain the requirements for an opening he had to fill—for general ranger. Luckily I had the broad skill base and law-enforcement training—he offered me the job on the spot! I had a month to get ready before reporting for duty in early May. How do you pack for five months in Mount McKinley (and prepare for your life upon your return)—all in four short weeks, while performing full-time ranger work?

In the 70s a park assignment in the Lower 48 states paid $3 to $4 an hour. In Alaska, with a cost-of-living allowance, I would make $5 to $6 per hour. The end result meant that I would earn just enough for school tuition and my room and board. So, I lived off sunrises and sunsets. The hardest part was coming up with the money for a $550 airplane ticket to Fairbanks. With a hand-to-mouth budget and about $150 a week in pay, the ticket would take almost a month's wages.

I had to sell many personal belongings to upgrade my camera. I do remember, in great detail, purchasing a Nikormat FT-2 camera after selling my Praktika to a ranger trainee. I also bought two special lenses for my new camera body, a 55mm micro (Nikkor) and a 200mm

telephoto, a second-market used lens. With five rolls of Kodachrome 64 film, I was eager to document the adventure.

* * *

I arrived in Fairbanks in early May at about 9 p.m. with $48 to my name. I found out that another returning ranger named Jim would be in Fairbanks the same day I arrived, picking up supplies. Just maybe, I could get a ride with him to the park. The fear about this tight connection and my even tighter budget flew with me all the way to Alaska. Jim was about my age, and picked me up in the used car he had bought that day to use over the summer. I felt indebted and offered gas, dinner, and cash, but he had just eaten, had a car load of food, and had a full tank. He said we had a whole summer to get even.

Those next few hours after arriving in Fairbanks are among the most indelible of my memories. Then and now, the unique landscape of Alaska was a major influence in my life, and I sensed the magnitude of it. Arriving in this land was a personal summit, with the tallest summit in North America in plain sight.

Following the dirt roads around Fairbanks, we stopped at a store that looked more like a warehouse. My remaining few dollars were used to buy nonperishable foods: dried beans, flour, sugar, cereal grains, powdered milk, peanut butter, preserves, and a quantity of basic staples. Jim had four or five shopping lists from other park people, and systematically went at filling them.

He told me that in his first month last year his food had spoiled, but I could see by his quick shopping decisions now that he'd gained experience from last summer. When we finished it was late by any clock, but it was still light out, and people were going about as if it were the noon hour.

Everyone we crossed paths with had something more than hello to say. They all seemed to be in a hurry, but still carried on with all sorts of news and information. All kinds of scattered conversations ensued, covering weather (naturally), road conditions, climbers in trouble, and the like.

One man asked, "Where are you from?"

Jim piped up with, "Salt Lake City," and I said, "Big Basin."

"Where's that?" a second man asked.

I elaborated, "A redwoods park on the Monterey Bay, south of San Francisco."

Shiny red bear berry leaves create a colorful mosaic with green Labrador tea leaves, golden grass stems, and scattered blueberries, cranberries, and crowberries.

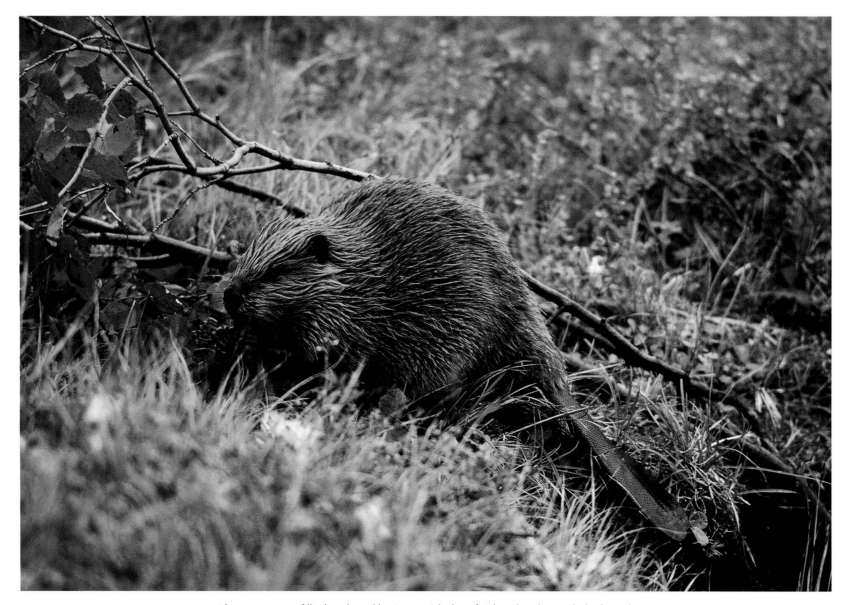

A beaver gnaws on a fallen branch to add to its watertight dam of sticks and mud across the kettle pond.

Twenty-two

Jim asked, "What did you do there?"

With pride I said, "I was a trail ranger on the Skyline-to-the-Sea Trail."

There were friendly words from everyone, essentially telling me that I was in for a treat in McKinley. Jim added, "There aren't any trails to talk about in McKinley, maybe a few game trails."

"Really?" I asked, "No one has developed routes yet?"

"No," they all chimed in at once.

Then Jim explained, "It's tundra, and it wouldn't help having a trail, and besides, more people use the river bars to hike."

One of the men pitched in, "You have two million acres and more up there—where would you put a trail in?" He ended his question with kind laughter.

There followed lots of talk about the state of the road and its potential impact. One gentleman asked me directly, "What job do you have?"

I said, "I'm not sure, but the phone interview highlighted the new road and potential enforcement."

A boisterous round of laughter rang out. Eventually one man summarized: "Don't you know, we're all draft dodgers, criminals, survivalists, and recluses out here? How are you going to tell a wild group of Alaskans to do anything? How much are they paying you to do that?"

I replied timidly, "Eh, um, GS-5 plus cost of living."

Jim quietly replied, "About $8 an hour."

The youngest man, about my age, chimed in, "I'm making $25 an hour plus a per diem and overtime on the slope serving food in a work camp cafeteria. We're all here to pick up monthly supplies for the camp. We have enough stuff to fill a whole airplane."

I asked, "Is this for the pipeline?"

He replied, "Yep, crude from Prudoe Bay to Valdez!" He added, "If you get beat up in your law enforcement, I'll get you a job cleaning up or making beds for $1,200 a week."

My curiosity ran wild; I wanted to learn about the North Slope environment, but the guys chimed in that they had to get going. Jim invited them down to the park and there was good cheer all around. Jim and I got into his sedan and the "boys" jumped in their truck, and were gone in seconds.

Later, on another dirt road leading to the park, I asked, "Where does the pavement start?"

Jim answered, "It's still in sections. Most of it is finished south of the park to Anchorage."

I said, "Nice guys back there in town, eh?"

Jim replied, "Everyone talks to each other here. That's what I like, even if they don't agree."

I asked, "Do they really make that much money working for the pipeline?"

Jim quickly replied before I was finished. "Yep, that's part of the problem in the park." Obviously, I'd hit a sensitive chord, and I contemplated his response. He added, "The park has to pay entry maintenance workers three to four times what we make to attract anyone because of wage-grade laws. This causes a problem between visitor services and maintenance divisions. Rangers are not even close to equal."

I asked if he ever considered working the North Slope and he replied, "I'll be out of school next year and ranger work will look better on my resume." I said I needed to save $2,300 for college tuition from my summer work. Jim said he made at least that much, and besides there was nowhere to spend wages, except through the L.L. Bean catalog. I was truly in a whole new world.

* ✳ *

It was close to 11:00 at night, but it seemed to be more like midday. We had to pass through construction zones and be led through tundra frost heaves. Before we came to this delay, we spotted different views of the Alaska Range. We traveled through tall aspen and white spruce forests, with McKinley standing tall in the distance, 150 miles away. Along the tundra elevation, small black spruce created micro-ecosystems around them. These habitats filled out the sparse mosaic of the predominantly treeless tundra landscape.

The air was so clear it lacked any sort of odor. The snow had receded significantly, revealing brown tundra. The dry air temperature measured 40 degrees F. The low-angle sun cast a warm hue on the landscape, clouds filling half the sky with a rain scowl highlighting a full-spectrum rainbow off to the south. I wanted to stop and photograph, but remembered the gracious gift and luck of having a ride, and instead took that moment to thank Jim.

He said, "I had to come anyway; glad it helped you."

I mentioned that I was used to being independent and was typically in the position of helping others. He reassured me, and said that everyone at the park was hospitable. "You never know when you will need someone's help to rescue you, and besides, now I have a stored favor!" Denali was giving me many welcoming confirmations.

As we came closer to the Range, snow-layered mountains gave color to the sloping tundra. Rivers roared with moving water as we stopped to rest on a bridge. Here at midnight, an hour or so out of town, the twilight sky was layered pink, yellow, and blue, dusted with rose on the snow-capped mountains. I stepped off the gravel to look down at the raging river and heard a low *"AK AK WAK WAAK GO BACK GO BAACK GO BAAAK!!!!!"*

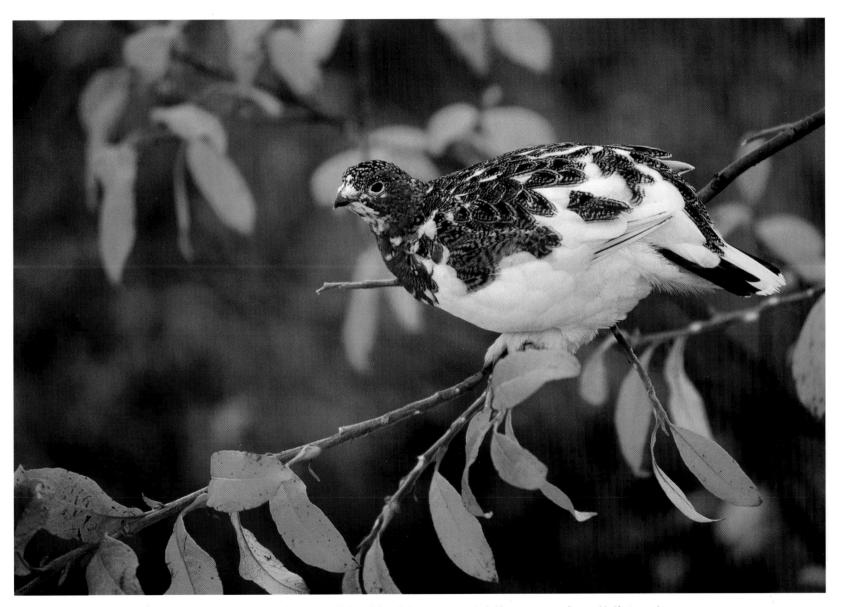

The willow ptarmigan is Alaska's state bird. This adult male is in autumn molt, half summer camouflage and half winter white.

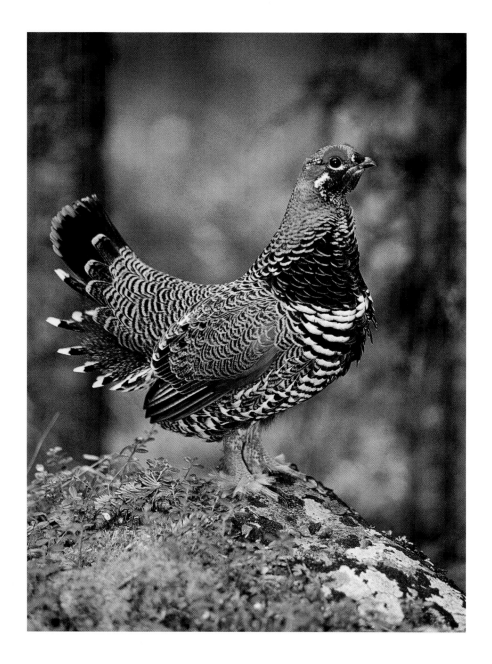

Startled, I could hear Jim chuckle and exclaim, "The Alaska state bird!"

I said to myself, "Bird? Sounds like a ghostly omen from a dying woodsman." I soon spotted a whitish, grouse-sized bird with a bright red eye patch. I had read about ptarmigan, but had no previous knowledge about their unusual call. When I returned to the car, I spent some time entertaining Jim with my attempts to imitate the sound.

We traveled along the river beside a willow lowland. I spotted several moose and got very excited, but Jim's second-season eyes barely gave them a glance. I was wide-eyed and mouth-drawn as we sped along, my neck rotating like an owl's trying to catch every movement of their large, horse-like presence. Suddenly, Jim slammed on the brakes as a young moose stood in the middle of the road, looking at us. Its legs were so tall, it appeared as if we could drive underneath it.

Small nubs of velvet antlers grew next to its extremely long and erect ears. He was a young male, maybe in his first or second year away from his

In full mating plumage this male spruce grouse posed during its courtship displays and drumming sounds that would eventually attract a mate. Spruce grouse inhabit spruce forests with dense undergrowth and may be seen along roadsides perched in trees.

mother. After we stopped, he moved off the roadway in slow motion. In an instant, he disappeared into the willows. As we drove on, his head peeked up between chews of willow buds.

Every turn in the road seemed to offer an education in natural history. It felt as though in an hour I had absorbed a huge quantity of factual, relevant information about Alaska. I knew that the intricacies and relationships of landscape, fauna, and flora were almost fathomless, but I felt a steady strengthening of the knowledge I had gathered at the University.

The sky was bathed in sunset hues for over an hour and a half until we reached the park in the wee hours of the morning. We stopped in front of my half tent/half wood-sided 10x10-foot cabin, encircled by a 3-foot-high snow mound, and Jim left with my hearty thanks. The cabin didn't need much settling, and I was drawn back outside, even though it was close to freezing. Nearby, a huge rabbit with extremely long rear feet stood on its haunches. A snowshoe hare, I proudly identified to myself.

This snowshoe hare stretches to reach the new growth along the bottom branches of a black spruce. Snowshoe hares feed on grass, buds, twigs, and leaves during dawn and dusk.

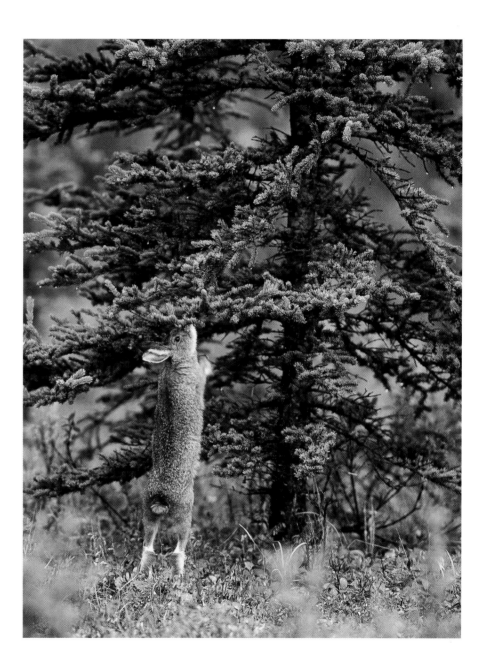

bond is closer than with many other larger and more accessible animals.

Perhaps part of this bond results from the beautiful surroundings high up on the rocky crags among the mountains, and the lovely vistas of sheep country. Here, everything hangs onto life by rocky precision points. The plants grow out of rock, the marmots and pikas live in the rocks, and the white sheep travel easily across the rocks. Their balance is keen. The wolf will challenge the sheep in hopes of a meal, but more often than not it's a losing venture, compounded with a paw hurt from the chase. Occasionally, a luckier wolf chases down an injured, sick, or young sheep for a meal.

Besides the wolf, marmot, pika, wolverine, and eagle, few larger animals are found living up in sheep country. And the eagle, wolf, and wolverine only visit this steep terrain, while the sheep endures the harshest of elements. The weather here is always colder and windier than that below, but the sheep have adapted to survive in this habitat.

A pastel rainbow highlights a view from Polychrome Pass looking into the Toklat River Valley as Dall sheep move along rocky cliffs. Dall sheep are the only wild white sheep and are the primary reason Mount McKinley was protected as a national park.

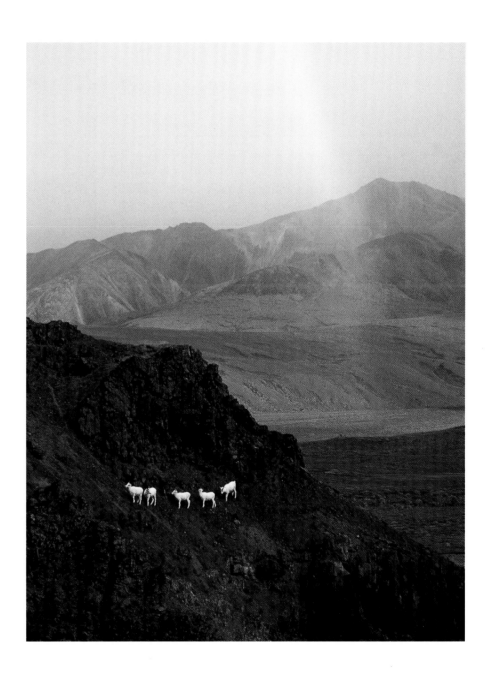

Thirty-seven

* ✳ *

On a rare day you may start uphill and hear the whistle of a marmot or the high-pitched "eeee" of a pika telling you it's going to be a windless high-country day. Pikas are small, rabbit-like animals that live in the rocks and are hardly ever seen when it's windy. I speculate it has to do with maintaining body heat and preserving their ability to hear their predators. My wife Karen and I have always called them our "fair-weather" friends.

A day with no wind means bugs—and maybe a few too many. I have been driven from a hike out of a canyon in full panic after several hours of mosquitoes so thick you could slice a wedge of air with a wave of your hand through a black cloud of them. Going up any ridge toward a source of moving air is the only relief from the constant buzzing. I am usually not terribly bothered by Alaskan mosquitoes, since they don't carry diseases. A few Alaskan mosquitoes are just enough to blur a photograph, that's all.

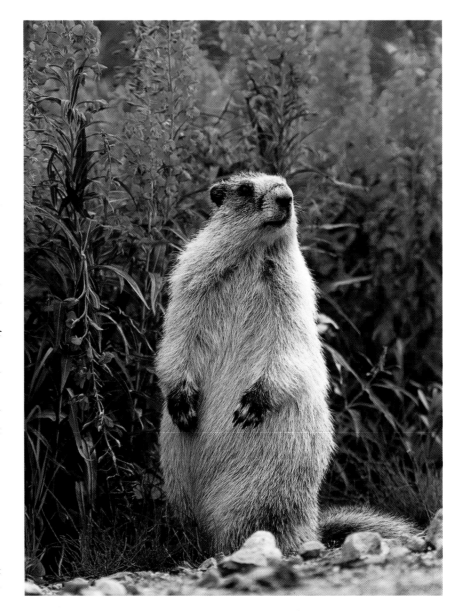

Standing to survey its surroundings, this hoary marmot is highlighted by a colorful backdrop of blooming fireweed.

The sheep don't seem to care about the mosquitoes either. Except for their nose and eyes, the rest of their body is protected. I have watched a ram chewing his cud in a resting position as a wasp flew by its mouth. The ram parted his lips as the wasp flew by and deftly added the winged tormentor to the rest of the cud. Many animals bite and eat insects. I think that they do it out of defiance more than for the caloric intake.

* ✳ *

Once up in the high country there is great opportunity to enjoy the sheep's view of the world. From these ridges, sheep can see a predator from miles away. Here the ancestral feeling of security and confidence flows through my bones also—the 360-degree view sweeps away any mysterious threat. I've pondered from such perches while a group of sheep made their way downhill. The one thing about sheep is that they never like anything, human or otherwise, approaching them from above. I've found that if I set up to photograph in a downhill alder patch a bit away from a group of sheep, they will oftentimes end up close by.

One such opportunity occurred during one of Karen's and my early years in the park. We watched, high up on Igloo Mountain, a large group of sheep resting above us. Our trek through the spruce forest was slow and worrisome—fresh bear scat decorated the forest floor. We had been frightened twice by moose, thinking they were bears. We were up in sheep country by mid-morning, and we found ourselves below a group of ewes and lambs. Karen and I placed ourselves at a 45-degree angle to the sun and waited for the best conditions to take a few photographs.

Later I moved uphill toward a carpet of grasses and small bushes. The sheep started to come down to me after about an hour. Karen, wide-eyed, signaled some anxiety about my safety. Her concern growing, she was surprised from behind by a young lamb and three ewes that began chewing on the bush she was using as a windblock. I watched as delight replaced the fear on her face, and she accepted the playful proximity of these puritans of the peaks.

Karen and I have spent a lot of time in the backcountry with sheep. During the summer, groups of rams split off from ewes and rejoin them in the fall. I have come across rams sporting horns with well over a full-circled curl and some half again that. Most often those rams have one or both horn tips broken off from battles in the fall rut. In combat, they rear up and slam heads with a thunderous sound. (I can't imagine what it sounds like inside one of their heads!) Before the head-slamming begins, they invariably urinate first. Then they run full steam toward one another, swaying their head side to side.

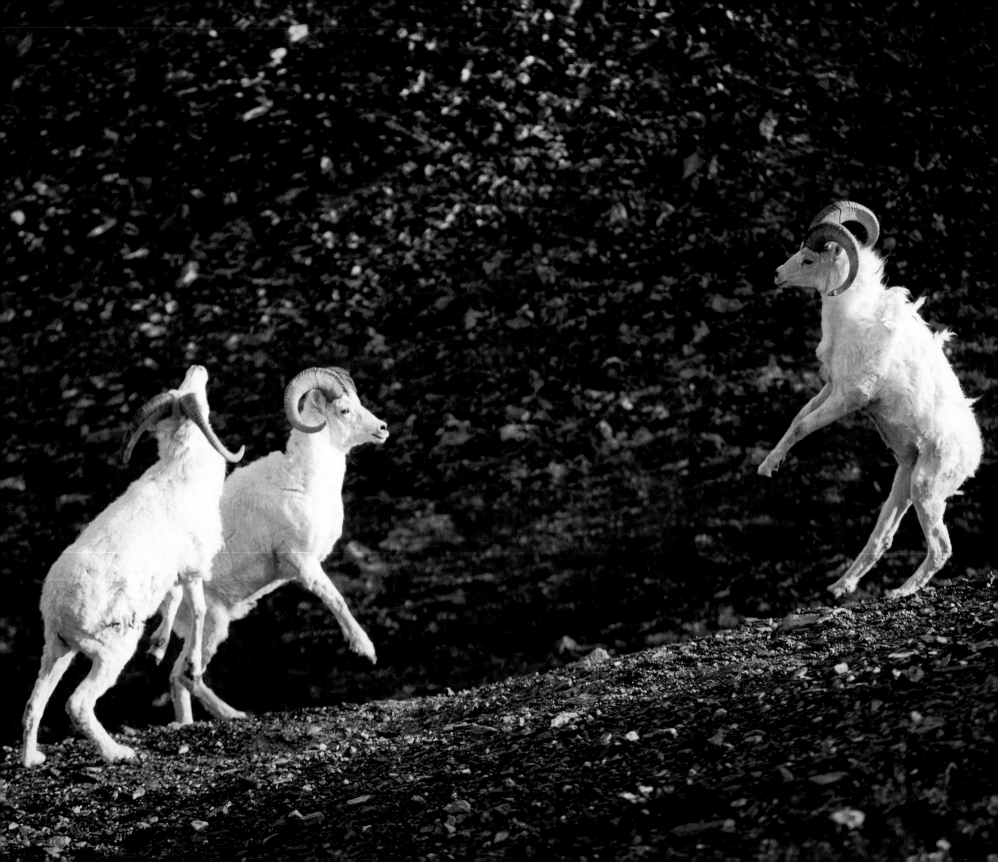

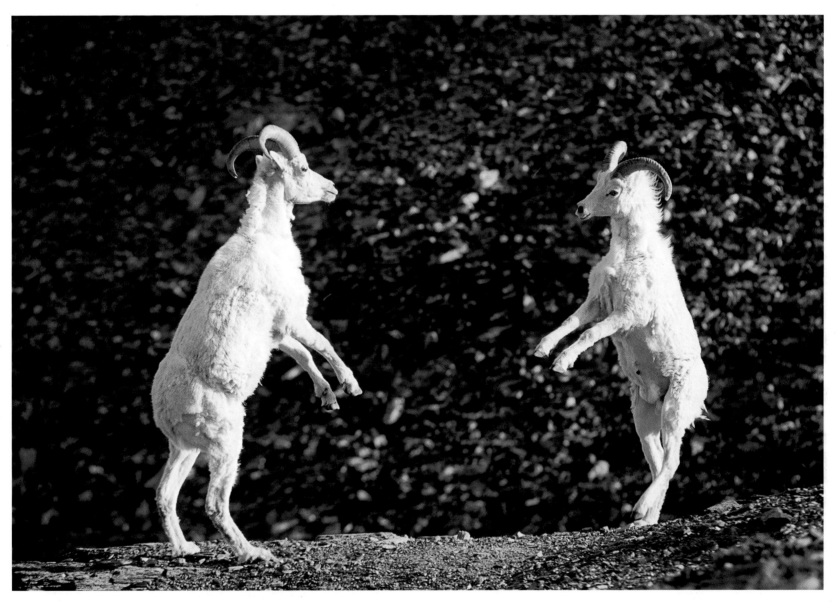

Dall sheep use their massive, amber-colored horns in fierce duels during the November through December mating season to establish hierarchy in the herd. Before the head-slamming, a ritual sizing up begins and they invariably urinate to musk the air as they walk away from their opponent. Then they run full steam toward one another, swaying their head side to side. Just at the moment of impact they dip their nose and tilt their head downward, slamming the tops of their horns together, creating a sharp, thunderous echo.

Forty-one

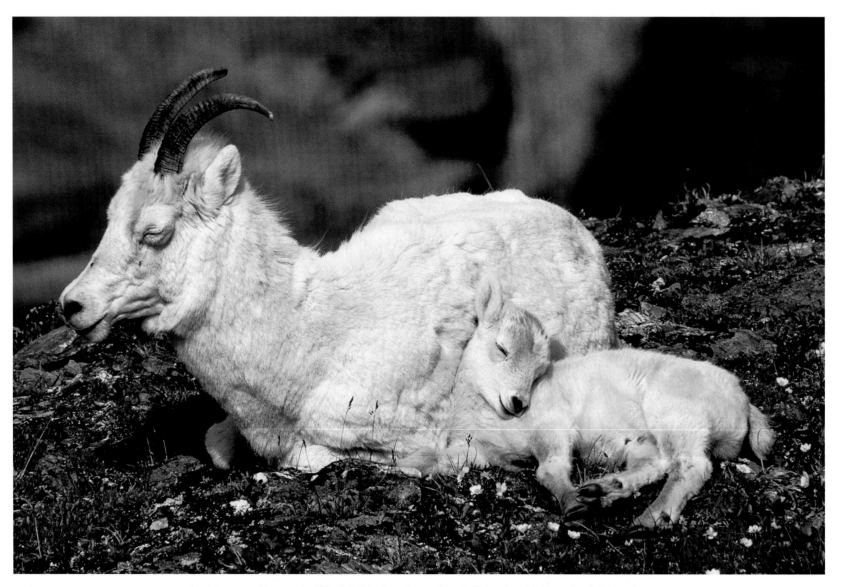

A mother ewe and her month-old lamb bask in the spring sunshine. Dall sheep breed in November and December.
After a 6-month gestation, a single lamb is born; nursing can last up to 9 months.

Just at the moment of impact they dip their nose and, head downward, slam the top of their horns together.

Unlike moose, caribou, and other ungulates that sport antlers, sheep have horns that are not shed each year. The female Dall sheep has short spiky horns, while the male's grow much longer. Each year the horns will grow a section or *ring*, sometimes 3 to 4 inches long. You can count these annual ring growths to guess the sheep's age. Most of the full-curl rams are over ten years old and their horns have many sections. These annual rings, like the rings of a cross-cut log, show the relative health of that year's growth.

During a winter patrol we found a skull and skeleton of a young male Dall sheep beneath Polychrome Pass. From the tracks it must have been an early winter death. The tall cliffs above might have been a factor in a successful wolf hunt, since there were plenty of wolves all along this corridor. However, any sign of predation was long covered by many snowstorms. What remained were skull and bones, picked fairly clean. The horns had five annual rings, making it a six-year-old ram.

In a dominant pose, a full curl ram displays his side profile to another ram to his left. This ram's left horn shows tip damage from previous battles. Horns are permanent growths from the skull. They tell us this ram is about 12 years old.

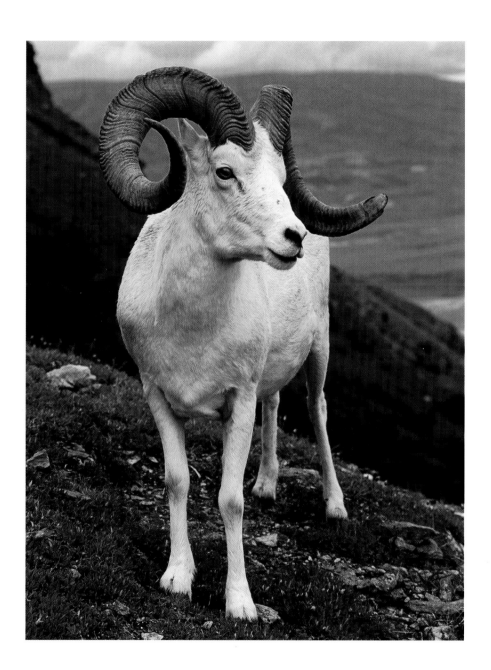

In the winter, with all the snow-capped peaks, hills, and tundra, it is nearly impossible to spot white sheep—they're worse than a polar bear in a snowstorm because the sheep are a lot smaller and tend to rest close to the ground. At least with polar bears you can see their mass moving across the land. In the summer you can see the sheep's white coat as a dot contrasting with the dark rocky outcrops. By fall, the leaves start turning color and the white coats stand out even more. As the first snows begin to accumulate, the sheep move around from one ridge to another following a traditional home range.

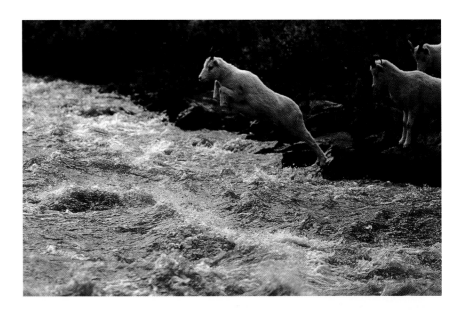

* ✳ *

One year, we watched as a herd of ewes and lambs escorted by a couple of rams came down from the east end of Primrose Ridge and crossed the Savage River mid-canyon. Not only did they cross the river, they jumped it! The big ram went first. He chose his spot, circled away from the river. With a running start and a high jump, he landed three-quarters of the way across onto a submerged rock, and then launched in one hop over the rest of the river to the embankment. I wouldn't have believed it if I hadn't seen and photographed it.

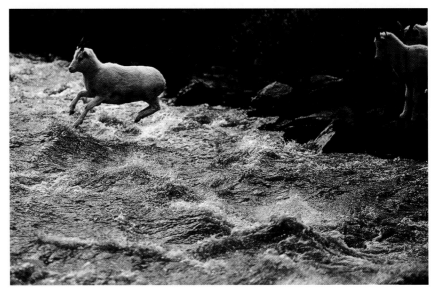

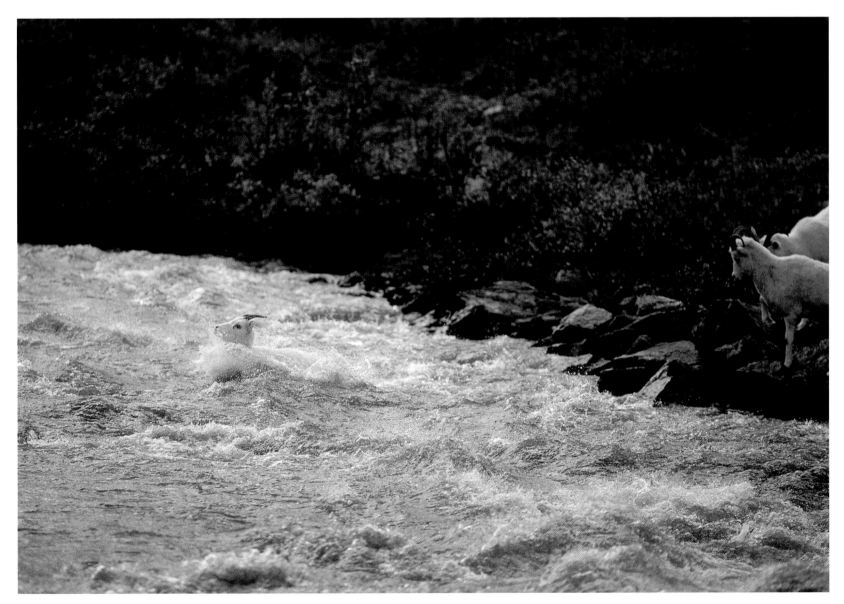

A rare photographic opportunity unfolded as a ram escorted a group of ewes and lambs across the rushing Savage River.
After pacing the shoreline for the perfect spot, one by one the ram, ewes, and lambs jumped in and swam to the other bank.

Forty-five

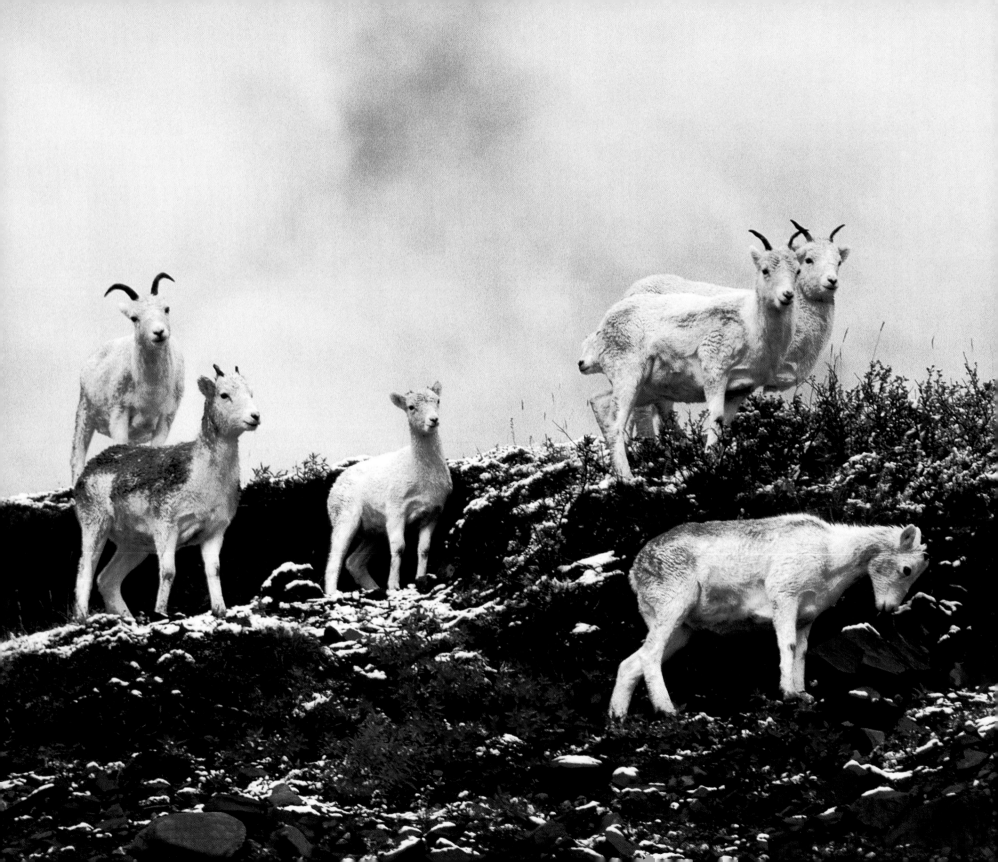

Next it was time for the younger sheep to attempt the crossing. Each one selected just the right place by pacing up and down the river until the choice was made. One ewe had a couple of false starts but finally took a third leap of faith. She made it halfway across and took a series of bounds and rebounds off the bottom of the river until she finally struggled up onto the riverbank. One after another they crossed until only one sheep remained. We watched for almost an hour as this sheep ran toward the river, false-started, and veered off to try again. She never carried through with a leap. She finally turned around and ran uphill back to the Primrose Ridge, separated from her herd.

I mused about the natural history taking place there.

I would have thought that kind of vulnerability or insecurity occurred only in human behavior. I can remember many times seeing people dive off cliffs or engage in any number of thrills; there are almost always those in the group that, for whatever internal second-guessing, choose not to participate.

That sheep was probably separated from its herd during the rut. It appeared as though the healthy and proven rugged ram had moved his harem to the East Savage Hills for the mating season. The one left behind probably found another group, but it left me wondering if there were other rams—like true champions—that could so deftly jump the Savage River and lead their harems to higher ground.

⌃▲▲⌃

A group of young sheep graze on the last stems of summer as a light autumn snow has fallen.

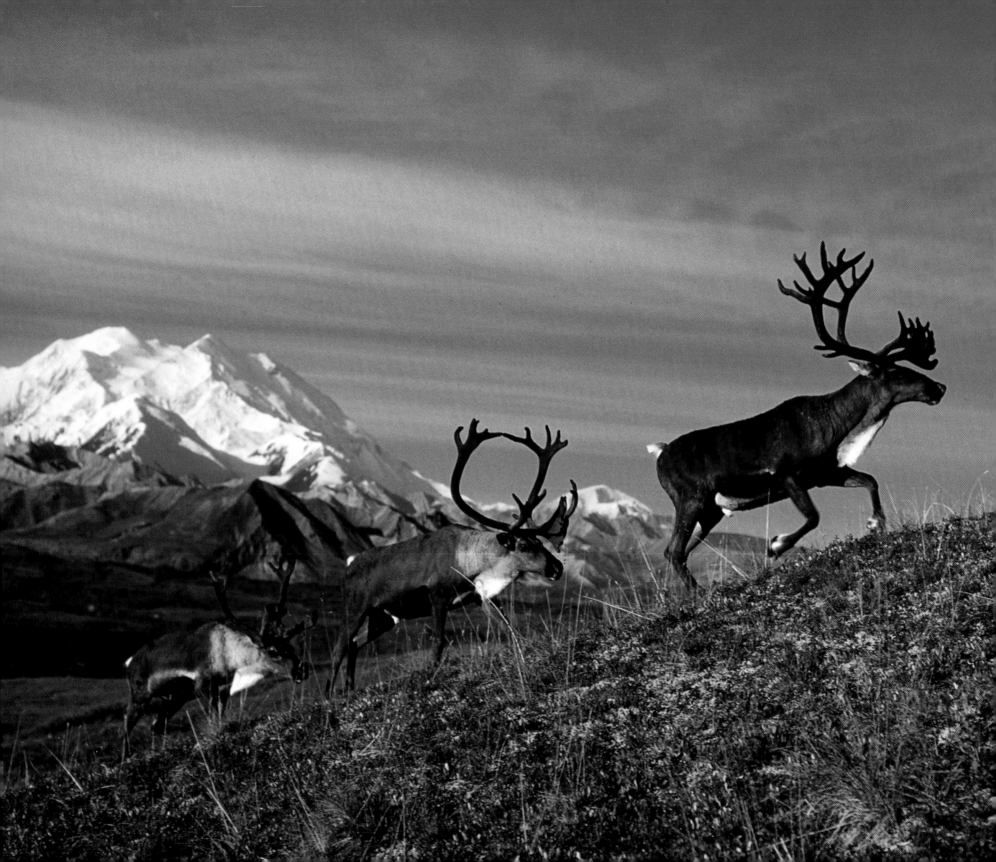

CRAZY CARIBOU?

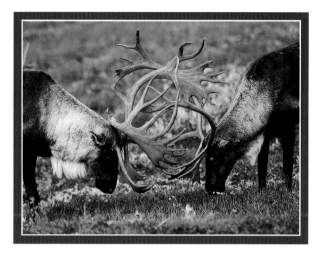

I've been struck by the notion more than once—
when pausing to watch a vast river of caribou move in union
across the Denali landscape—are caribou crazy?

I've gazed at a vast herd, thick in the distance as far as the eye can see, and occasionally one will rear up and jump around in circles, chasing away some invisible demon. What is bugging it?

Well, it's not just an eccentric whim. A bot fly has probably crawled up into the caribou's mucous membranes and it is so irritating it starts to drive the caribou mad. The rearing and jumping in circles is the caribou's attempt to escape from this torture. I'm thankful none of these flies has ever found *my* nose.

LEFT: Three bull caribou travel against the backdrop of Denali. Caribou keep moving in order to find adequate food and to prevent overgrazing. Because caribou migrate between pastures associated with calving, feeding grounds, and mating grounds, often several hundred miles apart from each other, habitat plays a critical role in their behavior and survival.

ABOVE: Caribou with trophy-sized antlers locked in battle.

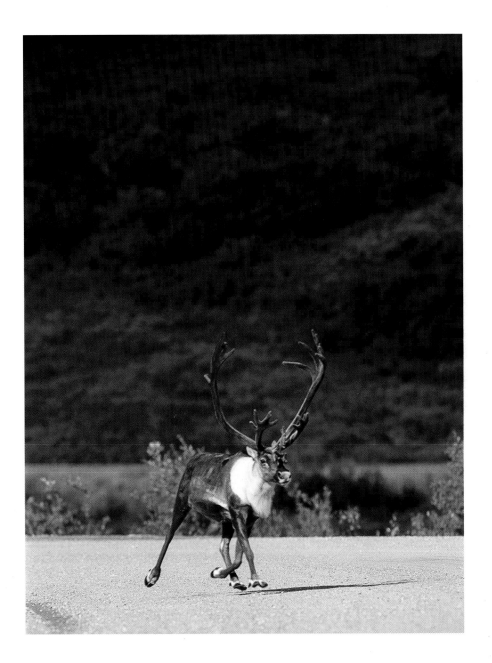

* ✳ *

I had been working in the west end of Wonder Lake one evening in August watching for moose in the kettle ponds. Driving down the road, I saw a bull caribou running full gallop down the road's center. I stopped and turned off my van to take a couple of snapshots. As he charged closer and closer, snorting and kicking, I began to worry that he might run head-on into my parked vehicle. I announced my presence without him taking any notice of me. Then I banged the door shut and he abruptly stopped in the middle of the road.

He stood 25 feet away and was completely still for a ten-count. Then, as quickly as he arrived, he turned and raced back, retracing his steps, snorting with his head down. He ran up the road a mile, then off around a kettle pond and over a ridge out of sight. I could tell that the mosquitoes and the bot flies were getting to him. I had one of those strange mixes of "beast empathy" for the pain from those buzzing antagonists, and low comedy from the caribou's kooky behavior.

A bull caribou, trying to elude annoying insects, races down the center of the park road, deep in Denali National Park. This shot captures him in a fast-paced run—with all fours in mid-air.

After working with the herd of 180,000 caribou in the Arctic National Wildlife Refuge and with the wildebeest herds of the Serengeti in Tanzania and Kenya, I could compare their biology and behavior. The wildebeest would burst into displays of excitement, kicking madly and running in circles, out of control. Oftentimes it appeared as if they were feeling carefree during these bursts. All too often, the underlying problem was that bugs were relentlessly bothering them and driving them to mindless frustration. I felt the same way when I was stuck in a swarm of thick mosquitoes for two days in the Moose Creek drainage.

Caribou grow antlers, like all members of the deer family. But unlike other deer-family members, both sexes of caribou grow them, though female antlers are a fraction of the size of the male's. The bulls grow the antlers at a fast rate, up to an inch or more per day during the early summer. Some caribou have antlers that have grown up to 5 feet in length. As with all deer, a series of blood vessels deposit calcium, forming bone beneath a layer of "velvet."

Caribou eat a wide variety of tundra plants, especially willow leaves, lichens, dwarf birches, grasses, sedges, and succulents, consuming about 12 pounds per day. Adult bull caribou weigh an average of 350 to 400 pounds. The antlers are nourished by a protective layer of velvet that is shed in late August.

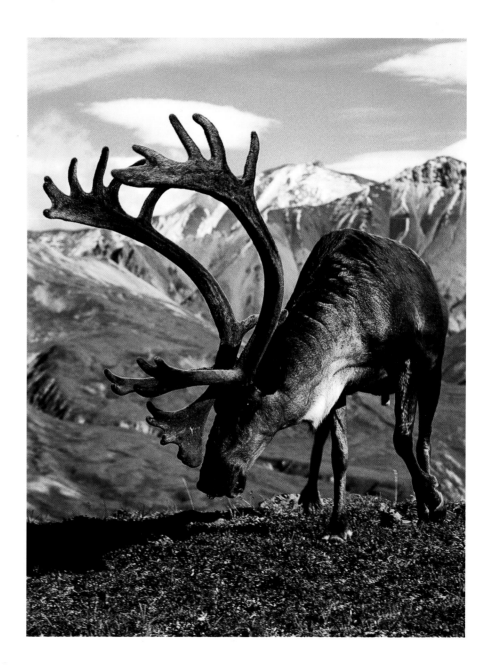

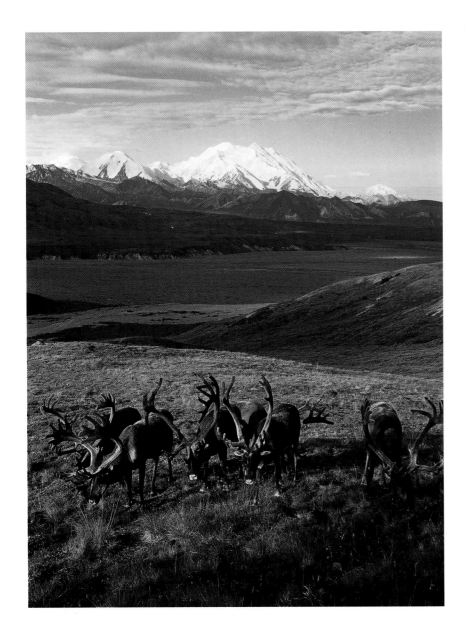

A small herd of caribou begin jousting for dominance with a spectacular mountain view in the background. Still in velvet antlers, these bulls only make contact with their hooves. Avoiding any unnecessary damage to their antlers, they have another month or so before the mating season begins, at which time they are ready for full antler-to-antler contact.

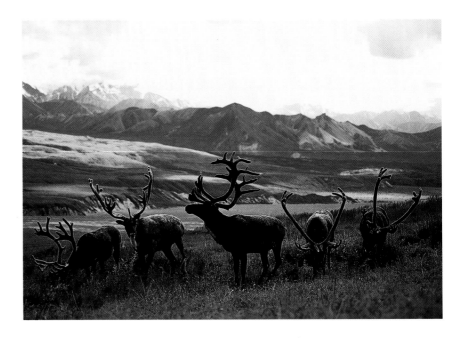

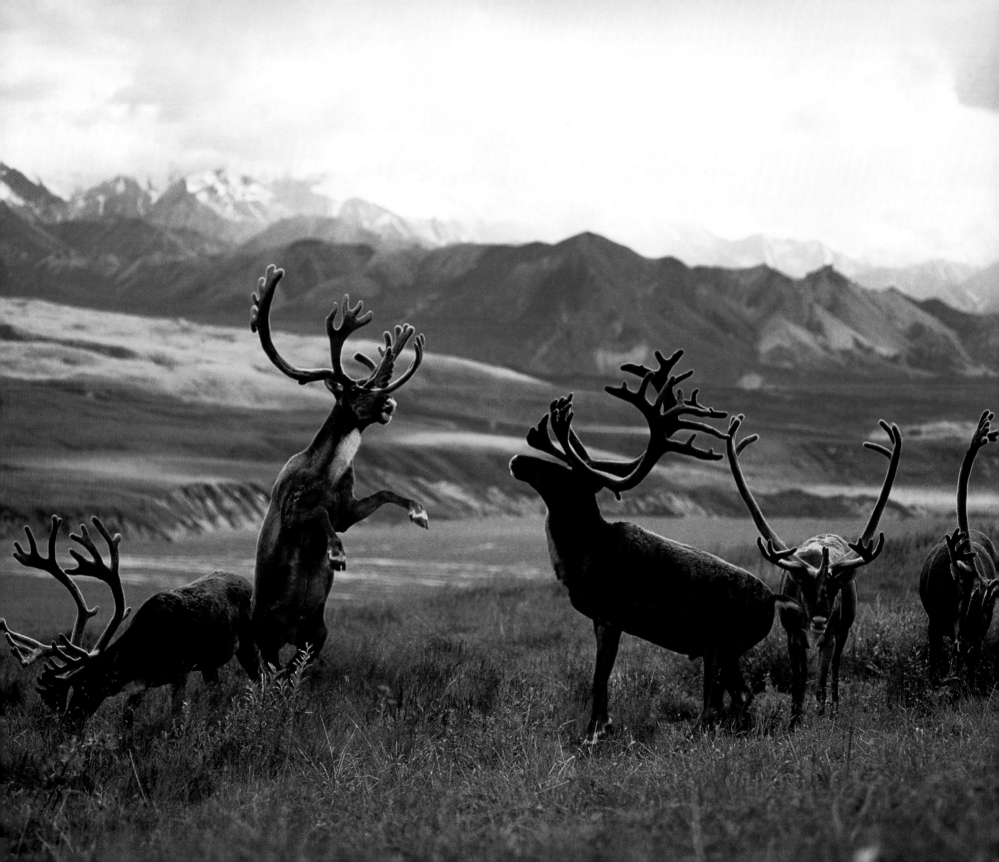

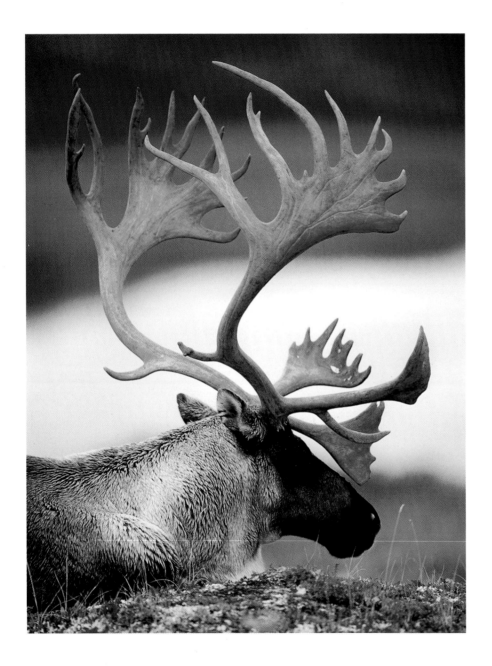

During the velvet stage of the antlers, any injury or antler damage causes deformation or atypical growth. Therefore, in the summer, bulls will protect their racks and avoid using them for battle. Instead, they rear up and kick with their front hooves. Both female deer and female moose do this as well. Once they shed the velvet, the antlers—and the animals— are ready for jousting. Male caribou battles are very active compared to moose battles, where it is primarily a pushing game.

* ✱ *

The autumn colors at Wonder Lake are spectacular, drenched with reds, oranges, and yellows. Picking blueberries (which we dubbed "Wonderberries") at that time is an Alaskan tradition, as ingrained in us as those of Thanksgiving and Christmas. Smelling the decaying leaves and the frost on vegetation stirs the senses. The colors of bull caribou antlers moving across the tundra add to the autumn scenery. Eating wild food such as blueberries brings us energy, joy,

A trophy-sized set of antlers with broad veins and extended points indicate this is a healthy bull in prime shape for the upcoming rut.

and thankfulness. And seeing the caribou as we pick Wonderberries is a good sign that bears aren't close by to challenge our patient harvest.

On such a berry-picking day, Karen and I looked up after hearing the sound of clicking hooves. Caribou movement is accompanied by this unusual phenomenon. Since their lower legs are designed for extreme cold—very slender with a minimum of muscle tissue—strong, hard tendons support the animal. Like a spring, these tendons snap the hooves back into a forward position when they run, creating a unique clicking sound. This helps the caribou direct warmth away from body extremities and back to its body core for survival.

As we sized up this bull, we quickly realized this was the largest set of antlers we had seen in a long time. The front shovel (the part of the antler directly over the top of his face) was not as prominent in heft as that of some other caribou, but his was the tallest and widest in memory. We had seen more points, but never a set as tall and wide. He was beautiful, with long white cape hair and a beefy build.

Caribou are the only species of the deer family in which both male and female members have antlers. The female's antlers are short, slender, and often irregular. Male antlers are large and may extend 4 to 5 feet beyond the skull. This male has the broadest antlers I had ever seen.

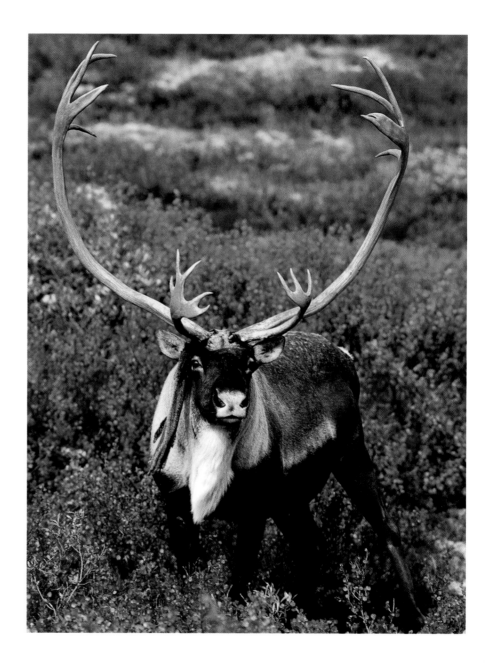

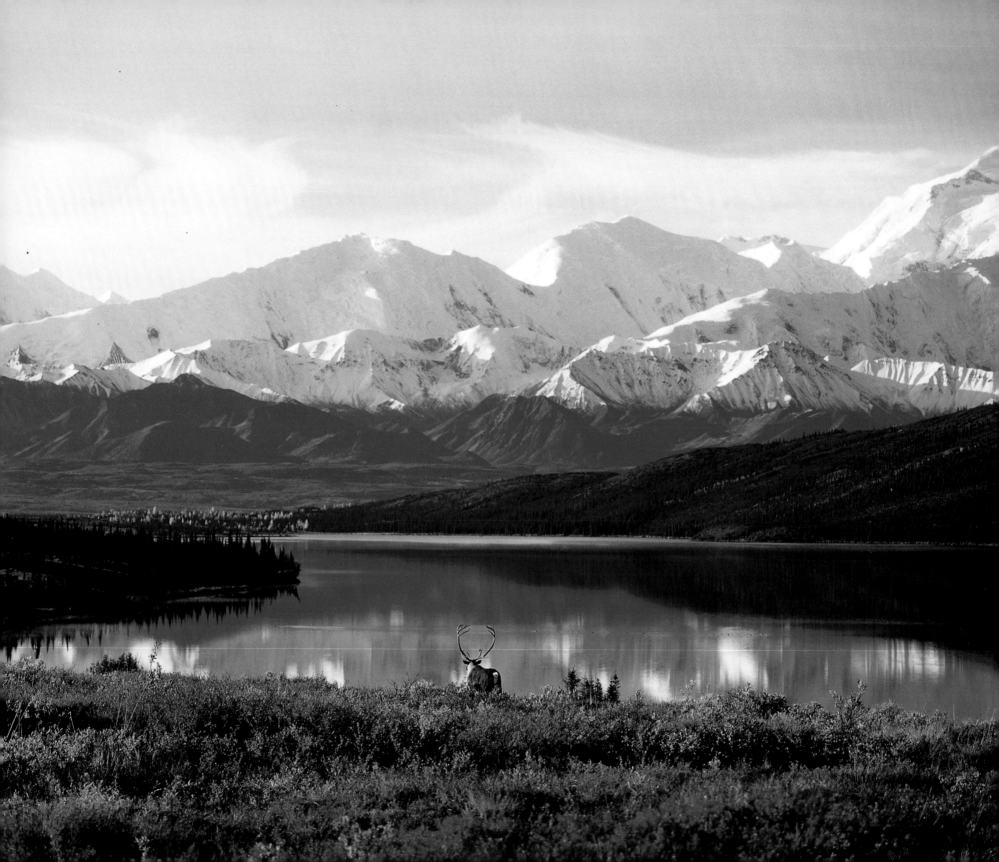

He stood nearby, eating lichen and mosses, but mostly the abundant blueberries. We held our hands up over our heads, standing still as he looked our way. I don't know if they think we are caribou when we do this, or if it just provokes curiosity. It's probably a combination of the two, but nonetheless he approached us as he fed. Since I only had a 60mm micro-lens for shooting blueberry and tundra, I would need him to get really close.

This magnificent bull made his way slowly toward us.

Eventually he came close enough for a striking photograph of a champion-sized caribou. He stayed around us for nearly an hour while we finished picking berries for our hosts, Candace and Walter Ward. We made preserves and two pies with the berries. We split one of the pies four ways and enjoyed it tremendously, thinking about the bull caribou, the autumn colors, and the smell of mountain air. Gobbling champion pies while considering champion beasts—not a bad way to spend an Alaska day.

Caribou feed on many varieties of vegetation including abundant blueberries, which add important fat-producing sugars to their diet. We call berries found along Wonder Lake "Wonderberries." Picking Wonderberries in the late fall is one of our Alaskan traditions, as ingrained in us as those of Thanksgiving and Christmas.

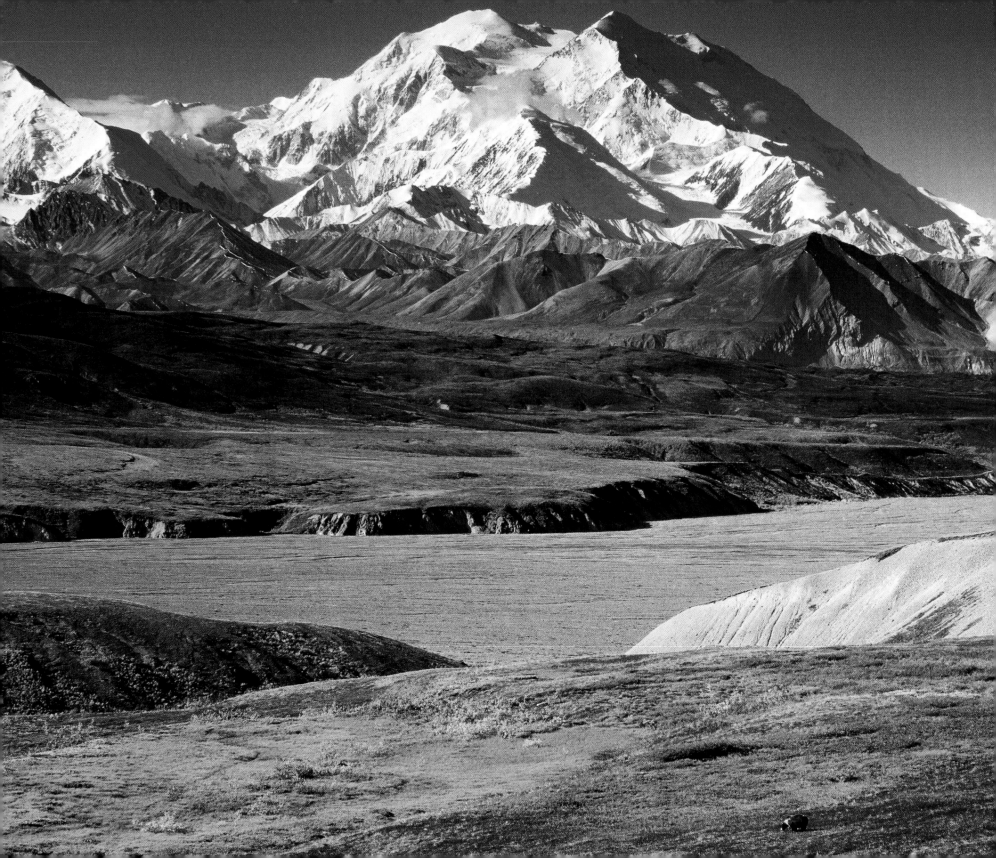

TOKLAT GRIZZLY TALES

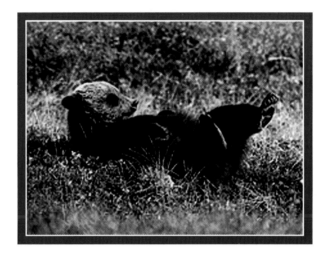

My first sighting of a Toklat grizzly was at the East Fork of the Toklat River in 1977.

The bear was so far away it was like viewing Denali from Fairbanks. Not until weeks later, while on foot, would I really have an "up close and personal" encounter with a Toklat.

* ✳ *

To my understanding, Toklat is a color, a graduated blond-to-brown hue, much like a surfer's hair that has been bleached by longtime exposure to sea salt and sun. The long summer days of sun paint the bear's upper fur with a golden hue. Their deep-brown-to-black legs lead up to the sunlight-bleached coat—a contrast that makes these bears the best-looking I've ever had the pleasure of observing.

The most challenging part of getting a good bear photo is to make its eyes stand out. Often, I've had to wait until the bear looked up and into the glare of the sun to be able to get that highlight from its eyes. Without the detail of their eyes, there often is no personality or "connection" in an image. We often rely on information we get from the expression in other human eyes, and the intent behind that expression. Cliché or not, looking someone—or some thing—in the eyes really can tell you many things, some truths among them.

LEFT: In the foreground of Denali, a grizzly bear roams the tundra in search of food. Bears in Denali National Park patrol a wide home range, feeding on berries, vegetation, ground squirrels, and carrion. Here along Thorofare Pass is one of my favorite views of both peaks of Denali. To the left is South Peak at 20,320 feet. To the right is North Peak at 19,470 feet.

ABOVE: A spring cub playfully rolls in the tundra.

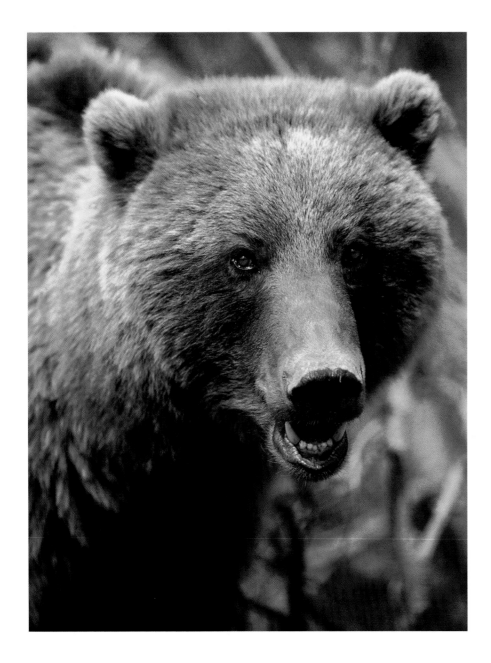

Of course, it's not recommended to be close enough to see the eyes of a bear—unless it's through a very long lens. I had little desire to see a bear up close, as the Park Service bear-encounter materials had scared me so much I couldn't sleep the night before my first backcountry patrol.

Movies, books, brochures, and stories had told how to avoid encounters: don't carry odoriferous foods, don't travel in brush, yell, wear "bear bells," sing. They also told what to do during an encounter: don't run, climb a tree. Looking around Denali National Park, I wondered, *what* trees? Much of the park consisted of vast landscapes of tundra. Learning about bear encounters was like memorizing the periodic table in chemistry class, only it was worse because the advice seemed strictly theoretical.

It wasn't until later, with experience, that I learned what worked and what didn't work. Bear-encounter actions and reactions depend on too many factors to have a rigid plan of action. The easiest example of this

This portrait of a Toklat grizzly bear demonstrates the classic dish-shaped face with the rounding of the side cheeks. In contrast to black bears, this grizzly has a shorter, less defined mouth or muzzle. Age can be determined by a variety of morphological characteristics including the distance between the ears.

complexity is the recommendation that climbing a tree will protect you from a bear attack. But if you climb a black spruce on the tundra, you might as well prepare to use it as a catapult to pitch yourself at the bear. A hundred-year-old tree would be slightly taller than a person and a lot skinnier, so it wouldn't make much of an escape. The lesson is that each encounter has a unique set of circumstances to be sorted out in advance to maintain a safety margin between human and bear.

There are no preventative means that will work in every situation either. How does one stop an urban crime or a hostage situation? How do we prevent ourselves from being mugged, robbed, or hurt? Stay home at night? Well, that is simple and boring. How do we prevent car accidents? By staying alert, anticipating the movements of other vehicles, blending into the flow of traffic, and staying unemotional. I try to apply the same techniques to wilderness survival situations. So far, so good.

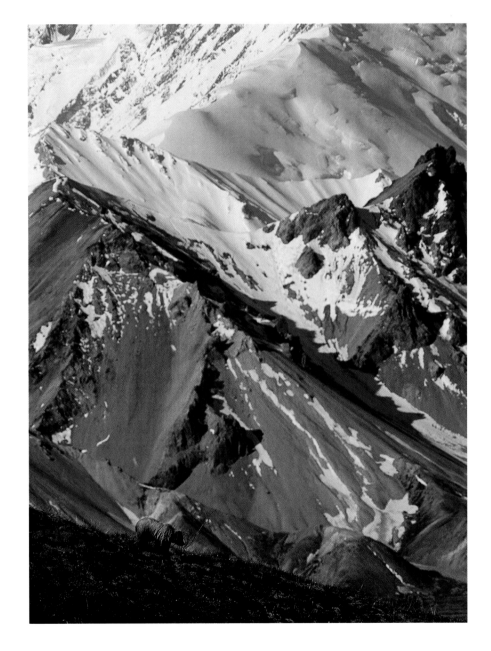

As a full-grown grizzly bear appears in the foreground, the vastness of the Alaska Range comes alive.

* ❋ *

Another bear safety tip is *don't hike in brush.* Well, on the day in question, I'd just hiked four miles in two hours and I wasn't about to just turn back without the fulfillment of a ridgetop view. No, I'd gone too far to give up. But the willows stretched along the entire creek rim, a creek only a stone's-throw wide. In bear-safety training I learned that willow thickets are a dangerous place to encounter bears because the element of surprise compromises safety.

I stood alongside that willow patch for a long time, my heart pounding in my throat, pondering what to do. The word *maul* came to me like something out of a bad dream. Then I thought, "Wait a second, I have a gun. They gave me a weapon. Only a couple of people in the whole park are allowed to carry a weapon. I shot a near-perfect score in qualification during training. What am I scared of?"

Yes, I could already imagine the headline: "Seasonal ranger from the Lower 48 shoots bear on first backcountry patrol." I might as well put that on my resume; my career plans would be instantly derailed. The park service should have just given me a two-pound rock to carry. At least I could have thrown it at a bear. But that thought gave me an idea: stones. With a pocket full of stones and singing "Yankee Doodle Dandy" out of key, I mustered up

the bravery to plunge into the dense willow, feeling my heart pound through my neck up to my ears.

It seemed as if every low-lying branch conveniently trapped the gum boots that protected my feet from the wet bog. My pack caught on every twig; I must have sounded like a bull in a china shop. I tripped, breaking a branch with a loud cracking sound. Halfway through, I was low on energy, high with frustration, and thoroughly filled with fear. I kept seeing the bear-safety lecturer in my mind. I could hear him saying, "I told you so!"

I guess fear must be a calorie-burner. And I wondered how I could feel hungry at a time like that! But keeping my mind occupied helped, even occupied with peanut butter and raspberry preserves on home-baked sourdough bread. I started to see blue sky through the willows and I quickly moved on. It must have taken me a half hour to climb through the thickets. Rushing toward an opening, I stepped into water up to my knees. "RATS!" I exclaimed, and struggled to gain my balance. A branch caught my other foot and down I went into the boggy muck.

I made a forward rolling motion to try to free my leg and exit the remaining willows. But the entire willow thicket was on a slope, typical of a streamside cut bank, and I fell forward, rolling out of the willows onto a gravel bar. I had rolled several times, ending with my hands out front braking against jagged rocks. "OOOWWWWWW!!!!"

rather than in anticipation of a good photo.

When I returned to the cabin, I found out that pizza and beer couldn't have tasted any better—the first treat in over three months. After dinner, Steve explained more about photography than I had ever been exposed to.

Then it began raining around 11 p.m. The rain fell lightly at first, then steadily, not letting up. After midnight, Steve suggested I go grab my gear and hit the floor of his cabin for the night. Hiking back to the camp, I couldn't hear the calming silence I had become used to—just the loud, repetitive drops of water hitting the puddles and leaves. I was getting a claustrophobic feeling from this sound curtain and the rain-caused reduced visibility. I had a quick intuition of something fearful that might lay ahead. Was there something out there, or was my concern just the change in weather and close proximity?

In the dark shadows of the spruce forest stood something: imagined, or was it real? My heart began to pound. Only halfway to the car, I stopped still. I couldn't detect a single movement. I forced myself to remain still and could sense something in the forest, twenty-five feet away. I moved slowly forward, my eyes fixed on the spot. Slowly, I continued my movement toward the campsite and the vehicle. No one else was in any campsite nearby.

As I moved to a better angle, I could see the form of a large body, much taller than I am. A horse-like exhale signaled that the animal was a moose! It remained completely still; I was relieved it wasn't a bear. I continued to move off and rounded the dirt road to the parked vehicle. Breathing easier, I gathered my camp gear.

Hesitating, I pondered the route back to the cabin. I hadn't brought a flashlight, having become accustomed to the light evenings, and the dimness was compounded by the heavy rain. I decided to take it slow, and hoped the moose had moved off. When I returned to the bend in the road, I noticed it had moved all right, right into the middle of the road, looking in my direction. This time I noticed the huge rack of antlers pointed my way. I quickly ducked behind a tree on the edge of the forest.

With gear clumsily occupying my hands and arms, I moved through the forest around the moose. Soaking wet from the spruce boughs, I left the forest on the opposite side, behind the moose. Still in the road, he had rotated to face me again, as if he had followed me with his acute sense of hearing. His massive, silhouetted form was very intimidating. Again he issued a horse-like snort, and I tensed. The bull shook his whole body, sending water droplets far and wide. I took this moment to move off toward the cabin. Steve was already in his bunk, and had left one gas light burning.

He said, "I was ready to go out searching for you. What took you so long?"

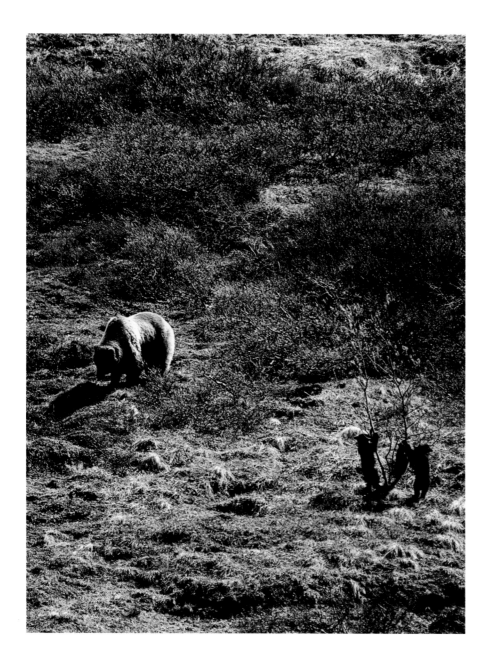

"Big moose you have around here," I stated.

"Oh, is that it? I thought a bear dragged you off. Turn off the light," he said between yawns and rolled into his pillow.

The next morning came early with a knock on the ranger cabin door. We were both up, dressed, and ready before answering the door. A man explained that his Toyota Landcruiser had flipped off the rain-soaked road because of the mud. Steve started the patrol truck as the man warmed inside the cabin. We all jumped into the cab of the truck and headed out to Igloo Canyon. We found the vehicle on its side in a flat, open area, and made sure nobody else was hurt. On the way back to Igloo Ranger Station we watched a wolf moving through the brush along the creek. Light colored and long legged, it followed Igloo Creek down in the direction of the cabin.

I said to Steve, "I wish I had my camera."

Laughing, Steve said, "The light is bad and he's a little soaked. Maybe he'll stop by the cabin."

At 8:00 a.m., Steve called a wrecker to pull up the vehicle, and I packed my gear off to my campsite.

Two spring cubs play with the bare branches of a willow tree. Playing with their natural environment, and each other, strengthens defensive skills and coordination necessary in adulthood. It is also very fun to watch.

On my walk I watched for the wolf, the bull moose, and the bear that was supposed to drag me off.

* ✳ *

The next night I had a Wonder Lake campground permit, at the west end of the park. Thanks to the overturned vehicle, Steve's early patrol shift had started even earlier. He had the next two days off and had planned to go into Kantishna and up Moose Creek to a gold claim. We made plans to meet late in the day at Wonder Lake Ranger Station. He mentioned that all the professional photographers had been watching bears in Sable Pass for the last couple of days and that I might want to say hello.

Everybody in the park knew that the photographers on permit understood where the animals were. If any of the photographers' vehicles were parked, wildlife was nearby. Not only did they have a thirty-day road permit, they knew the park like no one else. Some of them worked the park year after year, mining its photographic riches.

In an effort to preserve signs in the park, long nails are inverted to reduce the playful damage done by bears while "backscratching." This grizzly mother and cubs investigate this sign, smelling other bears' scents that have passed through this common corridor.

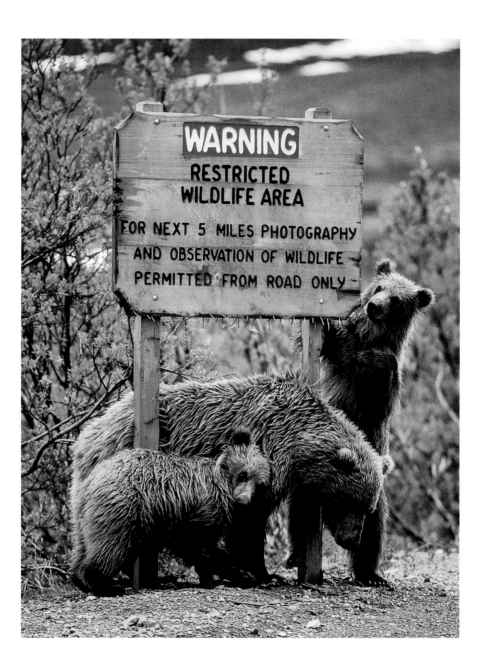

I was off, down the road and past the vehicle in the ditch, when I stopped in Igloo Canyon. It was still early morning and the rain had begun to let up. The whole landscape was fresh and quiet. As I looked up to Sable Pass through Igloo Canyon, beams of light announced the sunrise in reddish gold hues. Dall sheep were low, as clouds covered the mountains. I watched, captivated, as the young lambs ran around, up and over their mother. I can savor that moment today as a bookmark in my life—another unforgettable diamond in a timeless place.

I thought about the many rangers who might have stood in that same spot in the same early hours of decades past. We all watched the same landscape, maybe felt the same way, and the landscape reflected back what seemed like its eternal face. Only we have changed. For a moment, I felt some kind of ancestral bond with seekers of adventure, seekers of self-understanding, and seekers of a place in the world called wilderness.

I felt the true, here-and-now presence of the place, and a rich dimensionality to it all. My senses were full: the mountain range, the sheep, the creek, the fresh rain, the morning sun, the smell of fall in the air, and the quietness. I paused there awhile, passing the time as if in a magical dream, the surroundings confirming the heightened reality of this place.

Suddenly, I had a blink of intuition as I stood on that roadside. I turned to see a wolf coming up the road. It stopped and looked over the road and down into the creek,

as I had been doing for the last few moments. No farther than fifteen feet away, we surveyed in the same direction. This was a photo for the mind only. I didn't move toward the camera, as Steve had earlier denounced the canyon's poor light. The wolf looked at me as I looked at her. We were connected in a unique and profoundly personal way.

The happiest day of my life had just started, as the wolf marched down the road with me following, hoping for some sunlight to capture her behind the lens.

There was one set of fresh tire tracks on the dirt road ahead. As I rounded the corner, leaving Igloo Canyon and entering the open tundra of Sable Pass, I watched the wolf hunt a ground squirrel. I viewed the rare wildlife moment through my binoculars. It was too dark to photograph, as the sky was still gray from the rain.

After the wolf finished its breakfast, it returned to the road and continued on. Keeping my distance, I followed in my car. Ahead was a Volkswagen van pulled off the road. Two tripods identified the people as professional photographers. The wolf stopped on the hill and studied them, and they concentrated on it. The wolf started again as the man and woman swung their tripods around to catch some of its beauty on film. I hung back and waited until they waved a hello my way. I pulled behind the van, and as I parked my vehicle, I saw a grizzly bear not far uphill. Now I knew why the wolf had not stopped for the people: it had been looking uphill at the bear when it walked by.

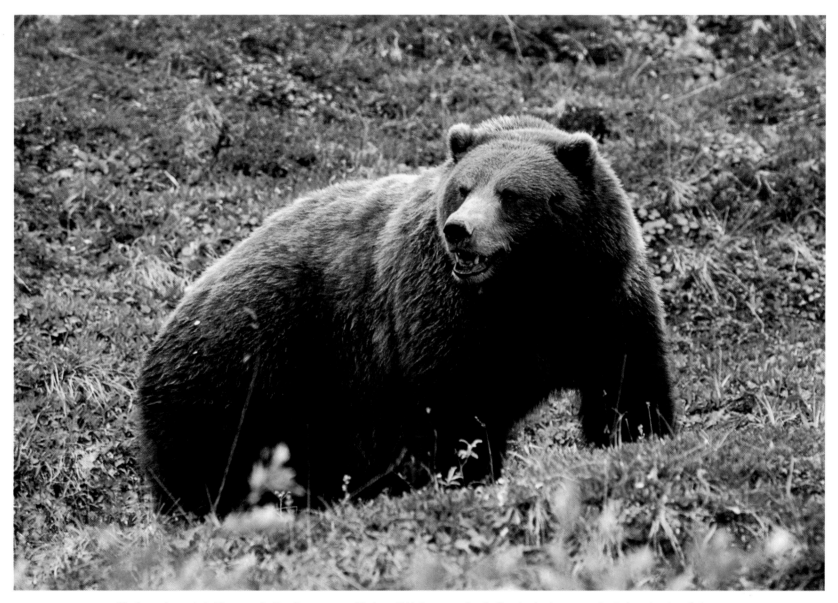

The largest boar grizzly I have seen in Denali moves across blueberry fields in an unending feeding ritual as he prepares for the long denning of winter.
Grizzlies are not true hibernators, which drop their metabolic rate 50 percent. Bears enter a winter sleep called torporization in which their respiration and heart rates drop by only 20 to 30 percent.

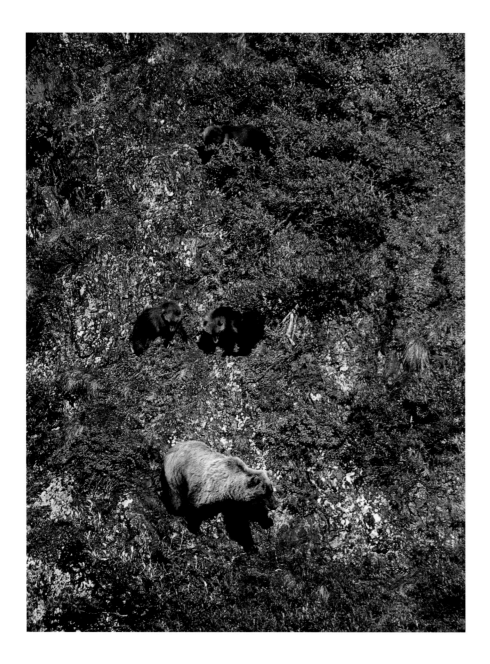

* * *

That was when I had the pleasure of meeting Cecil and Helen Rhode, cinematographers and still photographers, a middle-to-later-in-years couple known to me only from photo credits in magazines and park brochures. I was in the presence of living sages of the park. After a fair round of how-do-you-do's, Helen offered coffee and Cecil returned to his eyepiece, as my eyes returned to the bear a hundred feet away, feeding on berries.

"We have been watching this good-looking mother Toklat since Monday," Helen casually mentioned. "She hasn't moved far since then. You can't tell now because she is all wet, but she is a beautiful bear, and she has two spring cubs. The cubs are lying down in the foreground; use my tripod since the light is weak."

In a short morning, I had quickly advanced my knowledge of equipment and gained a learning tool by getting to know the professional crowd. I hoped that my photos would get better, as up to this point I had been disappointed with the darkness or with overex-

A sow leads her three cubs—which is a rare number—down a treacherous cliff. She has well prepared them to find many sources of food and face the challenges of living in a geographically diverse environment.

posed film. It was rare to get a decent exposure. I knew I had a lot to learn. What better company than these two professionals, who were so kind to this rookie.

Helen and Cecil usually put their vehicle on the train in the spring and left it up here all summer. I learned they had been coming up here for a couple of decades. There was no road from Anchorage then, and they took the train back and forth. I listened as they both shared the details of their Alaskan bush life since World War II. I was riveted. Cecil told of his winter journeys down to the Lower 48 to lecture, while he showed his movies to sporting and nature clubs and schools.

He and Helen homesteaded a parcel on Kenai Lake on the north end of the Kenai Peninsula, another favorite photography spot. They had a son, David, a little younger than I was, who attended the University of Alaska in Fairbanks. He was now off on a seasonal fish-and-game job, following in his uncle's path. Until this year he had summered with them. I could tell they really missed him, and for a moment maybe I filled those shoes.

What do bears really do in the woods? A grizzly scratches her back against a tree. Does this relieve an itch, or is it to leave her scent? Either action leaves behind hair and a scent trail in the bark to mark her range. Bears do not have a territory; rather, they carry a personal dominance hierarchy through their range, protecting their food sources and themselves.

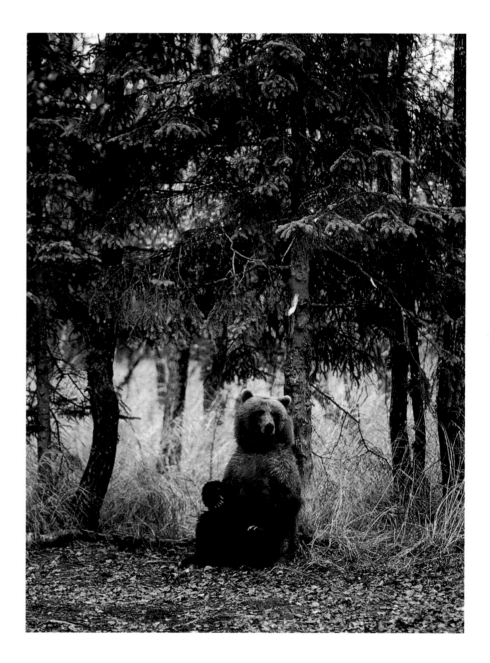

As we talked, the mother bear got up, and finally I saw the cubs. They were cute, tiny dark-brown spring cubs with a natal collar of white fur forming a ring around their necks. They fed with their backs toward us, moving slowly uphill.

Just then, a wildlife tour bus pulled over after spotting the bears. The commotion inside after the engine turned off was enlightening. The bears turned and faced the bus and the sounds of churning cameras. First the rapid clicking came from Cecil's motion camera, then Helen's, my own, and several bus occupants' cameras. After a brief survey, the bears turned again and fed, backs to us.

It was time to move on. In our separate vehicles, we three traveled the 86-mile dirt road for most of the day, stopping for any photographic opportunity. (I stayed behind a little, as I still felt out of their league.)

One of those moments came as we stopped when Helen noticed another, larger bear. In moments, the bear was moving quickly up to the road. Cameras clicked, including my own. The bear crossed the road and was up and over the hill in no time. I guess he had a berry patch in mind. The bear had passed as close as any bear had to me, including during my first bear rendezvous described earlier. As I stood still watching Helen and Cecil hold their ground and continue to work, I was happy to emulate them.

The rest of the day went by with wildlife encounters all along the road corridor. To my surprise, it was late afternoon when we finally stopped at Eielson Visitor Center at mile 66. By strong example, I had learned more than I could measure. I had also shot more film than I had all summer. Cecil and Helen decided to turn back toward their camp at Teklanika. We casually departed, knowing each other's itinerary. No serious good-bye necessary; it was obvious we'd meet again.

*　＊　*

I made my way slowly toward Wonder Lake, stopping for every ground squirrel near the road. Farther out, I saw a group of caribou feeding. I had only seen one bus returning east since leaving Eielson and began feeling more solitary—a good time to absorb and reflect on the day. My journal would show the ripple of energy caused by this day.

Only the lower half of Denali showed itself; the upper part seemed to create its own environment, filled with lenticular clouds. Casually, I found a patch of blueberries and fed myself without thinking. Another taste of wilderness, I thought; sustenance at nature's hands. One of many lessons today, and the sun was still high in the sky.

I caught up with Ranger Steve Kaufman that evening at Wonder Lake and we spent the night at the ranger station. Over the next few days, I had the privilege of spending quality time with several interesting people, including the miners of Moose Creek, the Wheeler brothers, and a

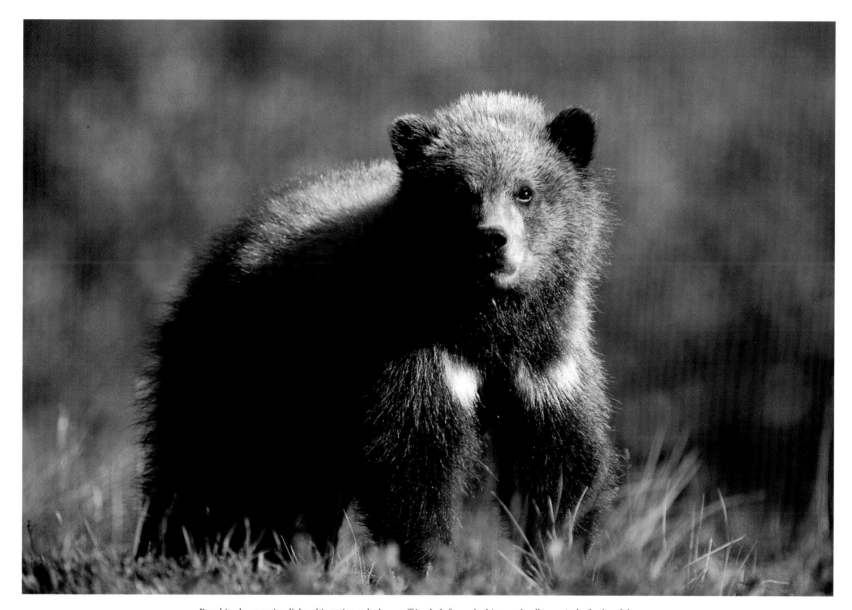

Posed in the morning light, this spring cub shows off its dark fur and white natal collar, typical of cubs of the year.

Eighty-one

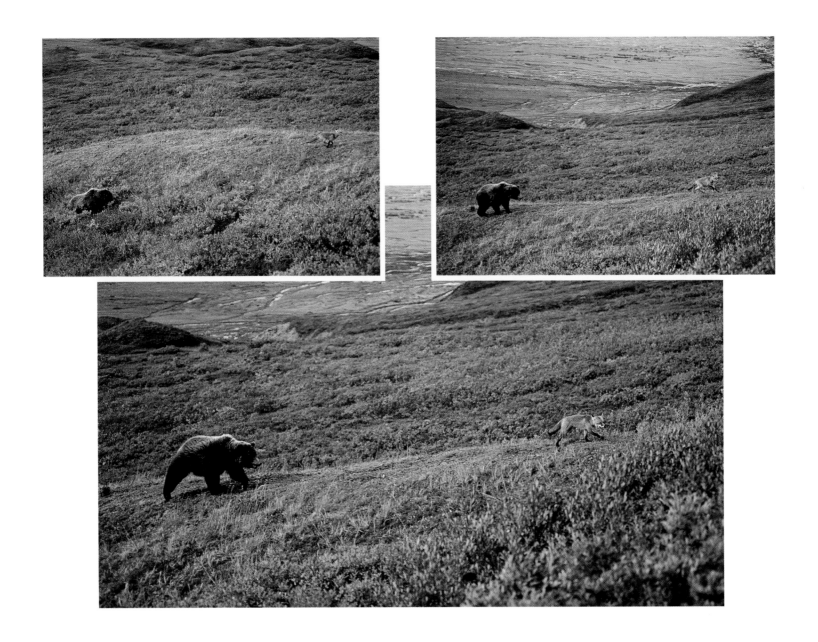

man named "Bear" and his family, among others. I also found a gold nugget with a natural hole for a necklace. Finding it, I thought that perhaps I might meet a fine woman someday to whom I could relate a story of finding gold in the shadow of Mount McKinley. Maybe I would find this woman the same way, sparkling alongside a stream, glistening in the rising sun of a new day.

It would be six adventurous years before the sun rose on this subject again. It was just before Halloween 1983 when I found another gold nugget. This one was about a hundred pounds, glistening in the sunlight of Capitola By The Sea: my wife Karen—a gem. I nicknamed her Nugget. For me, the name is a reminder of that significant set of days in the late summer of '77, days that added so much life to me.

Karen would soon join me in savoring the magic of animal encounters in the wilderness. Here's her account of an unusual grizzly sighting:

Once when Kennan was traveling with a friend in another vehicle in Denali, I was trailing behind in our van. The road ahead was curvy, and they had been out of sight for a while. As I wove through the curves, I could see they had pulled over ahead. Curious as to what caught their attention, I scanned the surrounding area watching for wildlife. I slowed down to ensure that I would not startle anything with my approach.

A rare scene unfolded: a grizzly bear in hot pursuit of a red fox. What created this interesting interaction? Was there competition for a food source? I hoped that Kennan was at a good angle to catch a photo, but I knew he would manage. Kennan had spotted both animals in the area and figured something interesting would happen. The two animals were busy eyeing each other, and then a chase ensued. The bear was excited, but the fox was swifter and more maneuverable. They flew past at high speed. I sat back and chuckled, knowing the fox was safe, as Kennan rewound film. Grizzly bears seem interested in anything—and everything.

Karen and I would share many such adventures in the future. But my first summer in Denali alone ended quickly, as any great adventurous time does, leaving me longing for more. My last memory of that period is a night shift in late September where the sky was clear and the air was cold. The aurora borealis moved along the northeastern sky, from horizon to zenith, dancing around the Big and Little Dipper, Ursa Major, and Ursa Minor. I watched the colors and patterns changing all night, mesmerized. Every time I see Ursa and the northern lights, I remember that last night of my "original summer," in my memory an endless summer. Denali to the south, and from the aurora, hope and dreams in the north.

⌃⋀⋀⋀⌃

Is it play or predation? Brawn and bulk are unmatched by speed and agility. In a sequence where a bear meets a red fox, a game begins of "catch me if you can." The cunning fox first runs then turns and waits for the bear, then runs and leaps just out of reach. Finally, walking slowly in a last tease, the fox continues this well-timed frolic for over a mile. No contact was ever made, although the game could have had a dangerous consequence for the fox.

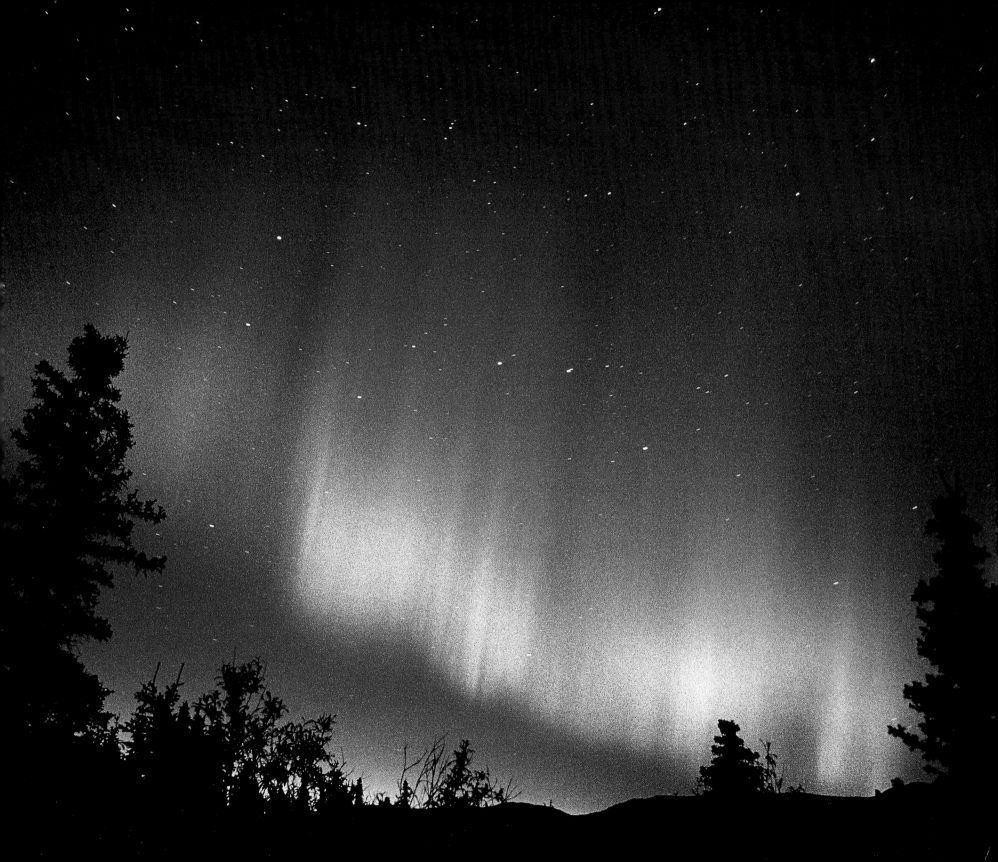

WINTER EXPEDITION

When Karen and I would come up to Denali in May of each year, we would get the usual razz about being from "outside." Folks seemed to go out of their way to discredit Californians as stereotypical yahoos with sand for brains.

In the years that followed, we learned that many of them were replanted Californians themselves. What intrigued me were the stories they told, like those of Wonder Lake in the winter. I heard tales of a winter wonderland of snow, scenery, and northern lights. I really wanted to work the winter to understand the full seasonal cycle, Californian or not.

For many years I had mulled over the "whats, wheres, hows, and whys" to work an Alaska winter. I considered Nunivak Island and its musk ox as a potentially great adventure. Covering the Iditarod for the news media would also be an engaging way to experience the winter. I'd heard compelling stories of winter sled-dog-and-ski trips in Denali by rangers and from year-round residents. Not that those weren't without their challenges, but they had been done before— I'd seen the pictures. One of the recurring themes in my work is to find something different or new. I had seen winter photographs of Denali, but mostly from the road corridor.

LEFT: Close to the Arctic Circle during the midnight hours, northern lights move from horizon to zenith, illuminating the sky with color—here with the Big Dipper, or the Great Bear, in the background.

ABOVE: In the Ruth Glacier a bush plane makes a snowy takeoff.

An idea came: photographing the northern lights and Mount McKinley from a south view, in the mountains, up close. I had seen and heard about the Ruth Glacier on Mount McKinley. I had seen its famous Sheldon mountain hut (at about 7,000 feet) in a photograph taken in the late spring. The hut was shaped like a small octagon and located on a precipice. It was originally flown in piece by piece and assembled by pilot Don Sheldon, who flew early climbing expeditions into the glaciers. The ice field surrounding the mountain is named after him: the Sheldon Amphitheater. However, I had never seen winter photos of the Ruth Glacier or northern lights from the south glaciers. During the winter of 1988, I made plans to spend a month up on Mount McKinley's glaciers in late February and March.

First I talked with the owner of the Ruth Glacier hut, Don Sheldon's widow, Roberta, who lives in Talkeetna. Roberta was very friendly, exclaiming, "No one has gone up there that early before; how about you clean up and fix a few things and I'll take a couple of days off the rent!" It was a great example of classic Alaskan hospitality.

She suggested that I contact Hudson Air or K2 to fly me up there. I had chartered flights over the mountain with Jim, the owner of K2, but I wanted to go up at least once with Cliff Hudson, the pioneer of glacier landing in Denali, who was still a working pilot. I talked with Cliff

and he wanted to go up, but was going to be gone during my time frame. He suggested I contact Jim at K2. They shared deep respect and high regard for each other.

Jim told me he hadn't flown in that early before, and that he would have to do two flights with the Super Cub to make a runway from a couple of touch-and-go's. I don't think Jim *or* Roberta really believed I was going to do the Ruth Glacier flight until I actually showed up in late February. I had asked everyone I knew, but no one, including Karen, was interested in going along. One friend tried, but after a couple of days in Fairbanks at minus 40 degrees F, he flew back home.

* ❋ *

Preparing for the flight at the airstrip, Jim and I organized gear and discussed strategies for success. Jim anticipated that in order to create a runway and land, we would have to do a series of touch-and-go maneuvers. We risked sinking in the deep snow up to the fuselage upon landing, in which case we would have to dig out the Super Cub. We both hoped that we would not break a ski—or anything worse—that might prevent the plane from taking off again. We anticipated takeoff and landing problems by bringing boots, snowshoes, parkas, and other survival gear, a lot of which we were already wearing.

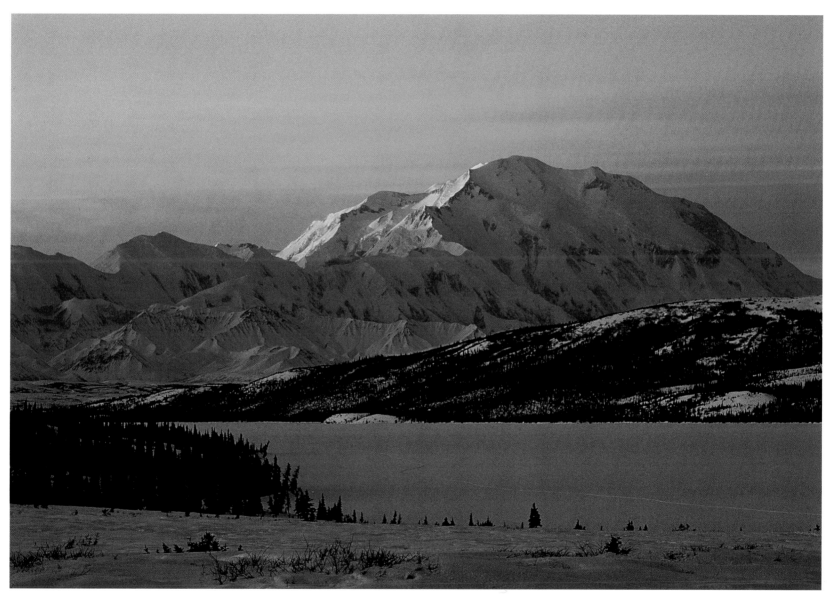

An evening alpenglow sweeps across the Alaskan sky above snow-laden Denali National Park in mid-winter.

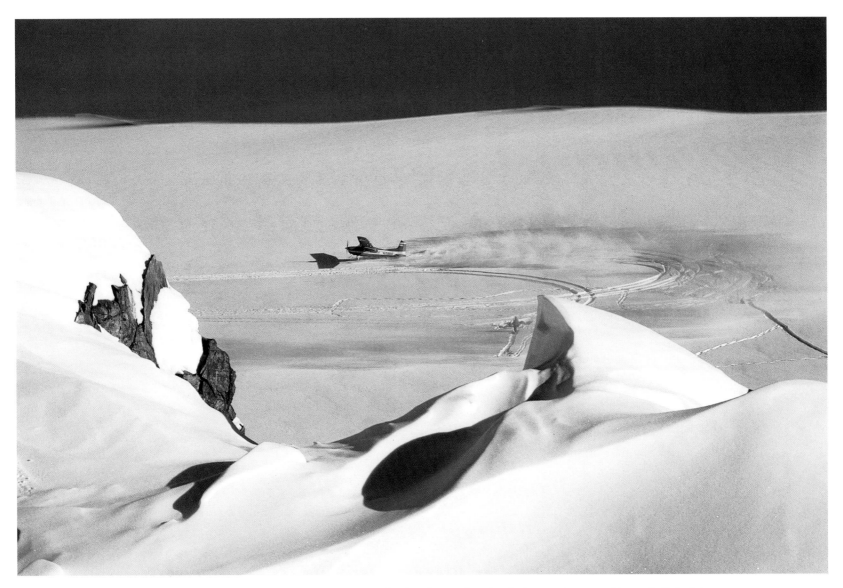

Landing a plane on the Ruth Glacier in mid-winter is extremely risky. After several touch-and-go's, to test the snow and ice, we finally landed.
Twenty-three days later the plane returned to pick me up—on the first day of spring.

Eighty-eight

It was still very much winter, although that particular day was unseasonably warm and clear. Flying up the Ruth Glacier, through the Great Gorge, past the Moose's Tooth, and into the Sheldon Amphitheater was breathtaking. To know we were the first people to do it since winter set in felt adventurous. Jim, too, was excited and was enjoying the flight as if it were his first. His concentrated confidence revealed many years of flying around "The Mountain" and Alaska. His appreciative looks at the landscape showed me his own renewed vows of affinity with Denali.

The touch-and-go's were like amusement-park rides, and Jim gained confidence about the snow from each pass. On the fourth pass, he decided that the conditions were good enough to land. The deep snow caused the skis to sink almost three feet. At the south end of the glacier we came to an abrupt stop. We then unloaded gear and began the task of pounding out a runway with snowshoes. Hours later, with the Super Cub under full throttle, I went from wing-strut to wing-strut lifting and loosening the plane's skis from the grip of the snow. We had to turn the airplane around and move it up onto our snowshoe runway.

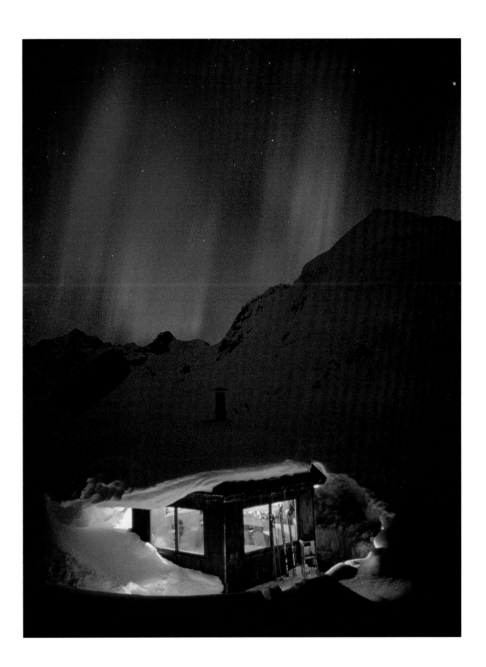

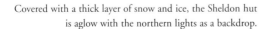

Covered with a thick layer of snow and ice, the Sheldon hut is aglow with the northern lights as a backdrop.

Eighty-nine

Finally, the Super Cub eased up onto our path and ran the runway. During the last effort to free the skis and push the airplane forward, the tail of the plane clipped me. I landed off the runway, in the deep snow. The wind force from the full throttle of the airplane motor had filled the air with fast-moving snow-spray. Blowing snow had lodged in my throat and I couldn't breathe. Finally, I swallowed by instinct and took a gasp of icy air. It was a while before the snow settled and I heard the plane echoing through the gorge. Again I inhaled snow, but this time I didn't panic, I just swallowed. As the sun began to set, I looked around and saw that all of my gear was covered in snow.

* ✳ *

The Sheldon hut was up on a precipice a half mile away, about a 600-foot vertical climb. No problem, right? With snowshoes I began what I thought would be a few trips. Because of the slope, I had to broaden my traverse to reach the hut. When I arrived at the top of the ridge where the hut was supposed to be located, I didn't see it. Only after a good search did I find its chimney sticking out of the snow. The sun had set about 3 p.m., and in the twilight I worked at clearing a path with a small alpinist's snow shovel toward the door of the hut. I made slow progress.

As if announcing the nighttime, a wind picked up and lightly swirled the snow when the sun set. Still sweaty from coming up the hill and working to free the hut, I felt a chill set in—and it remained with me for three weeks. When I finally cleared the entryway, I found the door hinges and lock had broken. Snow had filled the hut with five-foot drifts. Working by headlamp, I cleared the snow and retrieved my gear, bringing it up the hill. I set up the tent inside the hut, as I thought it might be better protection until I could repair the door. I was so busy that night I hadn't even had time to look up at the South Peak of Denali directly in front, an upclose view.

In the morning, I got out of the tent and stood and stared in awe at the magnificent vista for an unaccountable amount of time.

* ✳ *

Skiing around the Ruth Glacier was an otherworldly feeling, enhanced with a spritz of fear when the ice settled beneath me with a crunch and a bang. Feeling the moan of a glacier as you ski is one thing, but seeing an avalanche come off Mount Dan Beard magnifies fear to a new level. I set up a spike camp for day skiing in case I preferred to stay closer to the mountain, and for photographs of the northern lights. I enjoyed the tent and the view tremendously. Inside the tent, I used a lantern to warm the air above freezing.

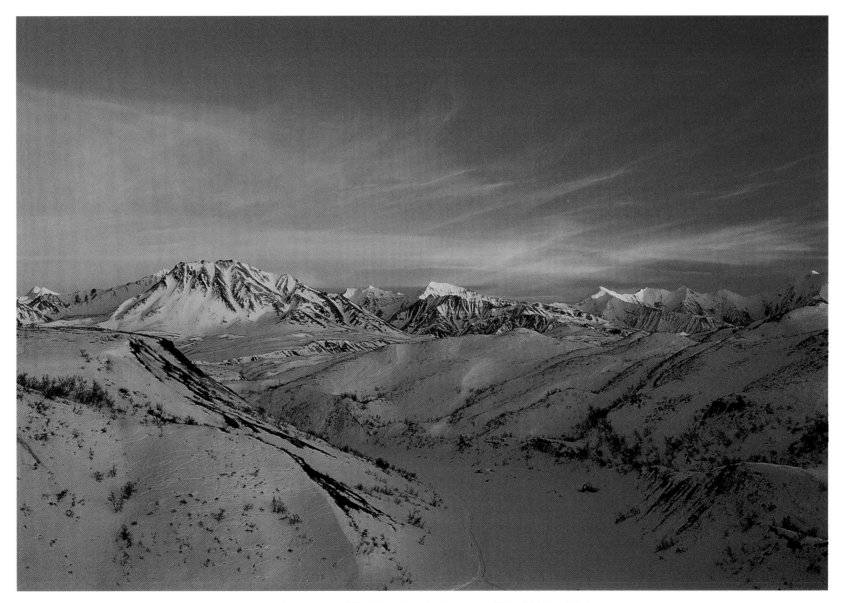

A midwinter view of the Alaska Range in the center of Denali National Park
highlights the many folds of landscape formed by glaciers during several advances and retreats.

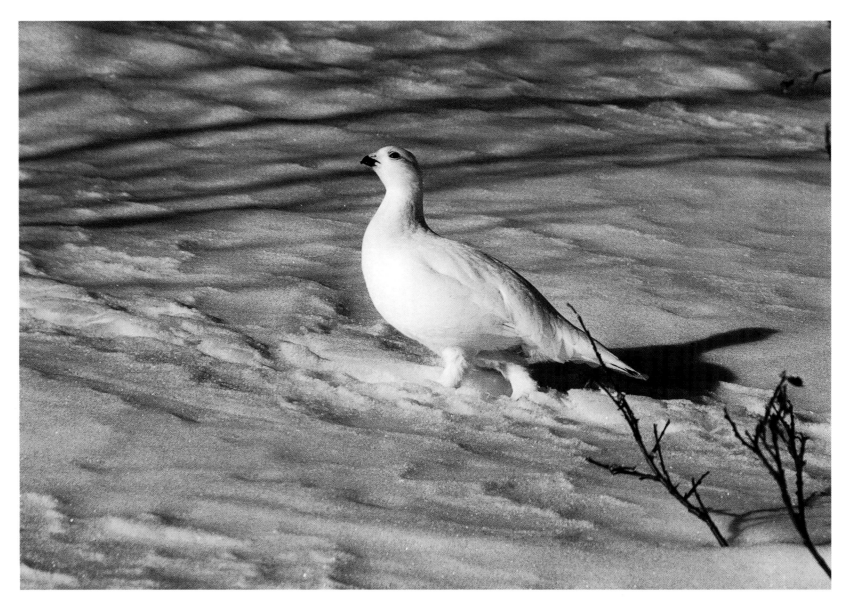

This female willow ptarmigan in full winter white plumage was a treat to photograph on a cold, cold day.

That trip taught me a lot about adapting to winter. When the skies were clear at night the temperature was frigid—my thermometer read around 25 degrees below zero. The daytime temperatures would get above zero, though the warmth from the sun made it feel like springtime. I stayed or tried to stay up all night, watching and hoping for northern lights. On cloudy nights, I slept and went for a ski the next day.

* ✳ *

The solitude and quietness afforded a different education. One night, as I watched an arc of green lights stretch about ten to twenty degrees above the horizon from north to east, a strange, introspective loneliness set in. At that point for me, any of modern society's confusions had vanished, and wilderness survival instincts ruled. That was the time for absolute reflection; no hiding from myself behind demanding events and people. As the northern lights intensified, I began setting up to take photographs. The stark, frozen landscape of the incredible mountain peaks of the Alaska Range added to the dimensional visual effect of the aurora borealis.

The red aurora illuminates the top of Denali.
In the foreground are my trusty tent, skis, and snowshoes.

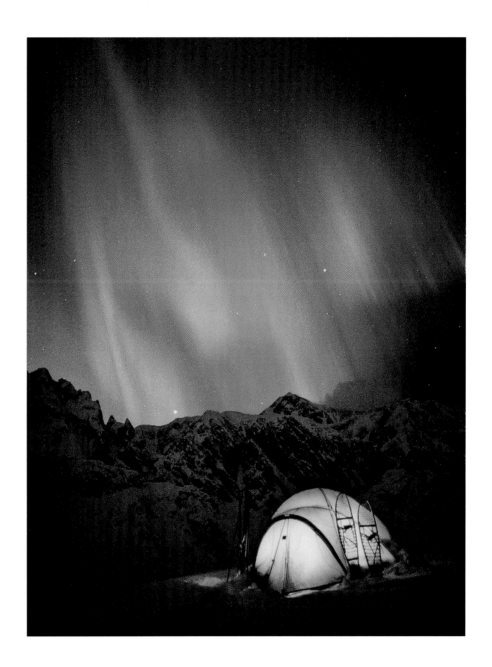

A green arc, glowing with the energy spit from the sun in a solar flare, produces molecules that are absorbed into our atmosphere. These electrons are accelerated to high speeds between the ionosphere and the semi-vacuum of outer space (5 to 50,000 miles away from Earth). Zooming along the curved pathway of Earth's magnetic field, they approach Earth's atmosphere at the poles. At altitudes of 50 to 200 miles, these electrons collide with ions of hydrogen, nitrogen, and oxygen, exciting them to increased energy, in the form of light. The source point of the speeding electrons changes position, causing the colors to appear to wave across the sky. This awe-inspiring phenomenon is still not completely understood, even today.

No Disney World laser show comes close to the beauty of the northern lights. The aurora built in strength and intensity and exhibited the color spectrum of greens, purples, and reds. I exposed film with the intensity of that red aurora while my thoughts were filled with joyfully contemplated reality. That night stays with me, a level of comfort with myself and my fate that I'd never known. It helped me to chart new hopes and dreams.

On a winter night, the clear sky is streaked with the varied colors of stars. This long photographic exposure freezes the paths of the northern lights as they roam across stars. Northern lights are rarely seen looking south. The weak color of this "green fog" aurora rises above Denali with Wonder Lake in the foreground. This 30-minute exposure catches a glimpse of Earth's movement.

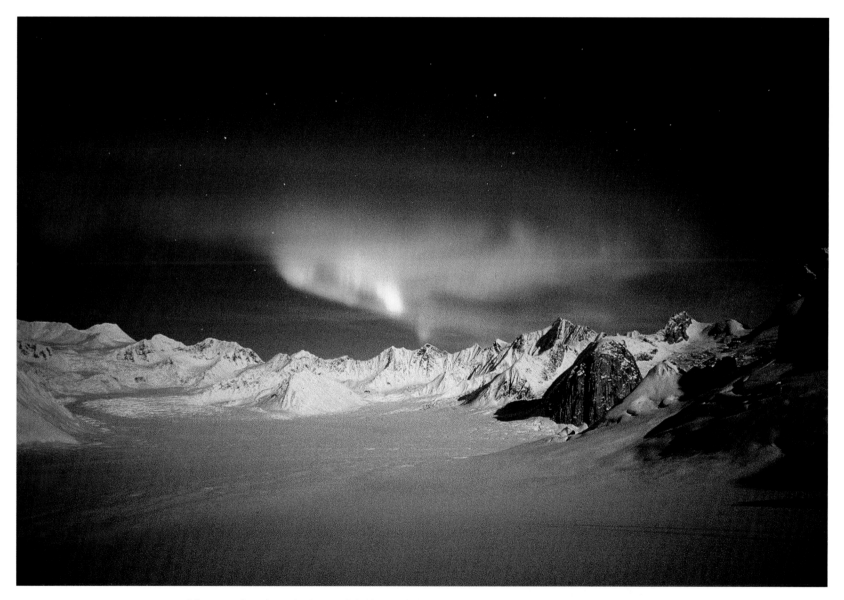

During a full moon night at the Ruth Glacier and Sheldon Amphitheater, the northern lights shine in an extremely bright whorl of green.

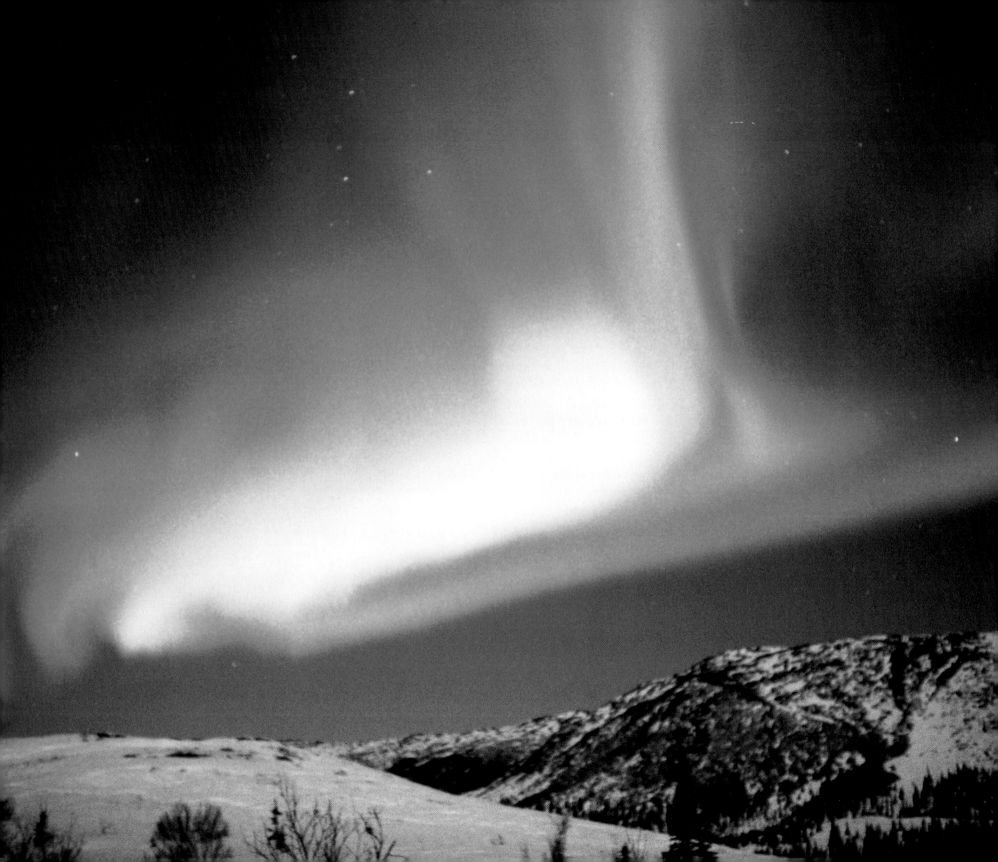

I can recall that night as if it were a photo. It generated a simple face-to-face with myself, something that seems impossible with the pace of modern life. I have had other rare, renewing experiences akin to this one, and now Karen has also shared with me these illuminating wilderness moments. Like a meditation, I can recall these peaceful backcountry interludes and rest in a heightened, clearer reality. Nature, for some, is more than religion, meditation, or a metaphysical experience. It helps many to crystallize a real moment in time, place, and self.

Sometimes I feel my time in wilderness is the only time I am really alive and truly me. It's all about nature, you, and the present. It's not a constant *either*. There is a crisp, brief awareness: details are magnified and inscribed. You know it when you talk with someone who's recently returned from a trek. You see some new gift of instinctual, surviving knowledge in their eyes. This essence is why people are stronger in will and judgment upon returning from a backpacking trip or an adventurous trek or some other sort of essential travel. They disconnect from modern-day demands and reconnect with something a touch more real—nature—and trust what they've learned through experience.

The following year, I repeated the winter trip to Denali. This time I connected with Cliff Hudson and flew up into Ruth Amphitheater midwinter. I had to return, since a lens problem had ruined most of my photographs from the first trip. The lens had frosted inside, adding an opaque ring to the center of the photos. I have learned since to avoid moisture, but any prolonged use of camera lenses in extreme cold causes moisture to accumulate and eventually risks Newton rings. But as you can see, it's more than worth it, for a high winter's wanderings in a champion park.

˄˄**˄˄**˄˄

In winter's full snowy dress the Kantishna Hills are aglow with moonlight and reflections of the strong display of northern lights.
They are one of Nature's true magical phenomenons.

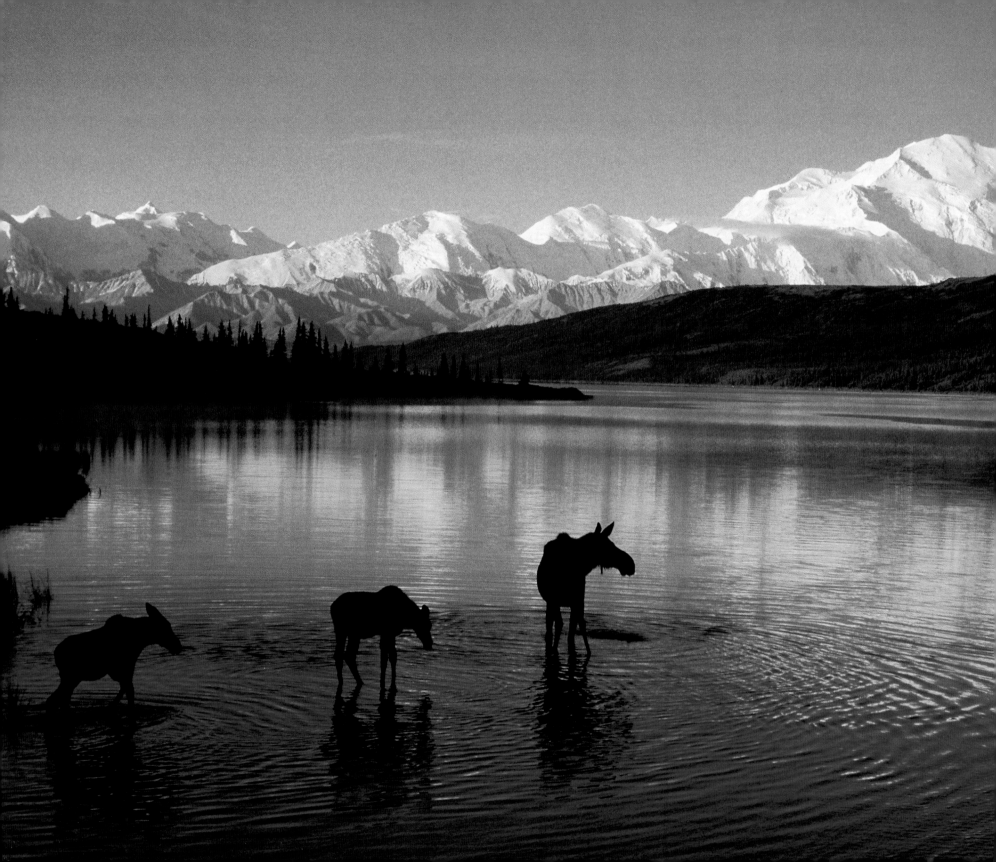

MOOSEWOOD

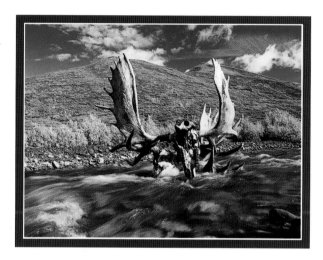

Each year in the spring, Karen and I head north to work an early season in the park.
Over the years, we had become increasingly close to Helen Rhode.
Her husband Cecil had passed on to The Great Land, and we all missed him.

We became great friends. Over the years, David Rhode, their son, became an even closer friend. We have spent a great deal of time with David and Helen in the park while on professional photographer permits, sharing wildlife sightings and coffee. Away from the park, we shared experiences along the Kenai Peninsula, close to their homestead.

Denali also shared some of its other admirers with us in the late 80s. Shane and Lybby Moore, a young couple from Wyoming, had the kind of sharing, friendly demeanor that felt right in tune with Karen and me. Cinematographers, they enjoyed working together in remote field conditions. This was unusual: very few photographers had a marriage to speak of, let alone a field mate or co-worker. They were a team, cameraman and sound recorder.

LEFT: A cow moose brings her yearling twin calves down to the shallow north end of Wonder Lake in the early morning hours to feed on pond grasses.

ABOVE: Near the headwaters of the Savage River two sets of moose antlers locked together tell the story of a tragic battle.

From the evidence remaining nearby, including hides and major skeletal sections, it appears as though two bulls were unable to unlock their antlers during battle and died face to face.

It is reasonable to speculate that wolves and/or bears gleaned the meat and other animals fed on the carcass, returning nutrients to the biomass.

Comparing the adventures of still photography and cinematography is a continued source of comic relief among the four of us. Shane and Lybby were a little younger than Karen and me, but were professionals with field experience. We met through having continually seen them at Hogan Creek, a small drainage where moose seemed to give birth year after year. Karen and I had spotted a very pregnant cow moose there, and had staked out watch cycles for three days at the creek.

On many nasty-weather days, photographers would visit along the road shoulder, sharing coffee. After we all got completely chilled one day, we noticed that Karen had been back inside the warm van for twenty minutes. Laughing at ourselves for standing out in the elements, we christened ourselves the "tough and dumb club"—a joke that remains to this day when we find uncomfortable conditions and have a chance to laugh at ourselves.

Shane shared information on what he had seen throughout the morning and revealed that over the previous few days he had been filming moose. I remember hearing his many facts about these largest members of the deer family and thought, "This guy is a walking moose dictionary!" He said he had seen our moose in the area and we both expressed the goal to photograph a birth, and possibly bear predation.

The Moores were on contract to make a one-hour program about moose for *Marty Stoufer's Wild America.* Maybe it was the interest in the cinematographer/still photographer vocation, or maybe it was an interest in moose; maybe it was a "couples" thing, or maybe it was their friendly, sharing demeanor, or maybe it was mutual respect or all of the above—whatever it was, it made for a lasting friendship to this day.

Shane and Lybby filmed their newborn moose calf close to the Sanctuary River and separately, we had our chance. At Hogan Creek, Karen and I took turns watching the cow that was ready to give birth. One night, we retreated to Teklanika campground after midnight for a few hours of sleep. We woke before first light at 4 a.m., and about 5 a.m. found a newborn calf. Standing at nose level to its mom, the calf was literally supported by its mother's face. And the umbilical cord wrapped around its hind leg made it anything but sure-footed.

I photographed in the shadows from the creek, leaning the camera against a tree, with a shutter speed of 1/15th of a second in the dim light. The mother held still and the calf could only wobble. They stood quietly with no apparent intention of moving. It was a stretch photographically, shooting in shadow light braced against a tree with a 180mm lens. Nonetheless, the experience carried the moment, and we were both enlightened by the opportunity to observe such a tender interlude. By luck,

the photograph of the mother and calf turned out beautifully.

Our permits in the park were only for early spring and fall. Our summer plans included the Arctic National Wildlife Refuge, Katmai National Park, and McNeil River Sanctuary, with other stops along the way. Shane, Lybby, Karen, and I made plans to see each other in the fall. The Moores planned to work around the park all summer. We all hoped to do some backcountry work together when we returned to the park in late August, through September, and into October.

* ✳ *

It was amazing how much Shane and Lybby had learned and understood about moose and Denali. Through patient observation, they discovered a great deal of information about the behavior and natural history of these big creatures. By the end of the summer, it was obvious that the Moores were adding to the understanding about moose and other animals, supporting the researchers' hypotheses and speculations.

One of my all-time-favorite photographs is this one of a cow moose with twin calves watching and listening attentively to a wolf nearby.

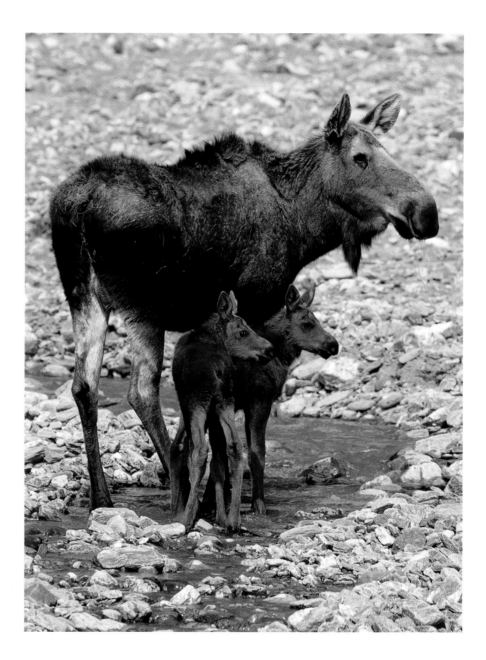

One hundred one

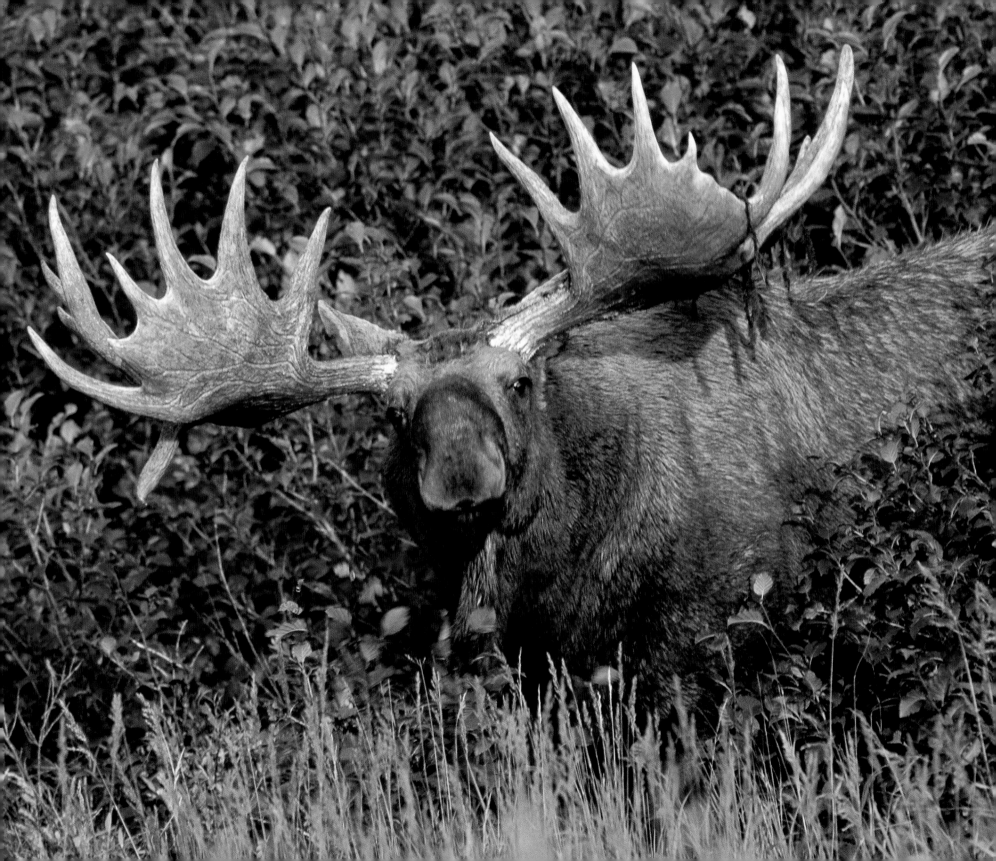

Throughout my academic biology and natural-history education, it had become obvious that field observations formed the basis for truly sound wildlife management understanding. Firsthand experience by field biologists is a luxury today. For people such as photographers, cinematographers, writers, and artists who spend most of their time in the woods, observation seems to illuminate more completely the cycles and complex relationships between habitat and wildlife. Shane and Lybby had dedicated more field time than many biologists and researchers. They exhibited in-depth understanding of the ecosystem.

On our first day back in the front country of Denali, Shane took us up the Savage River to show us a couple of bull moose. The animated Shane detailed these moose as real heavyweights. He had named them Tyson and Buster, after the then-current boxing rivals. Across the Savage River and upstream six or seven miles, we came to a spruce forest. In a flat, protected area, we chose a camping spot for later in the season. Our hope was that we could film the shedding of antler velvet now and return in late September to find these bulls with a harem of cows during the rut. Farther upstream, the mountains closed into a shallow canyon we called "The Gate." There we were to find one of Shane's heavyweights.

Across the Savage River, into another spruce forest, we traveled toward this large-antlered bull. By the time we had beaten through the brushy willows and over the boggy tundra in our hip boots, we got a close-up view of a record-size bull moose. When he turned his head parallel to his back, his velvet-covered antlers spread over half the length of his body.

* * *

Moose, the largest of the deer family, grow antlers each year, beginning in the spring, as an outgrowth of the pedicel, a frontal bone of the skull. Velvet is the term for the external coat around moose antlers. This specialized system nourishes the antlers through a layer of skin that supports fine hair growth on its exterior, thus its "velvet" dubbing. The antlers are fed through a vein and artery system much like any other appendage, although growth is rapid. The animal uses calcium to support the antler's growth.

In the older bulls, antler growth slows, and can occur at the expense of robbing calcium from their skeletal system. In early autumn, the supply of blood to the bony structure and velvet of the antler is terminated. The buildup of body fat triggers changes in hormones, and the

In a count of brow tines, this bull shows six and five on his front brow tines, with a rack spread reaching nearly half of his body length—a real champion.

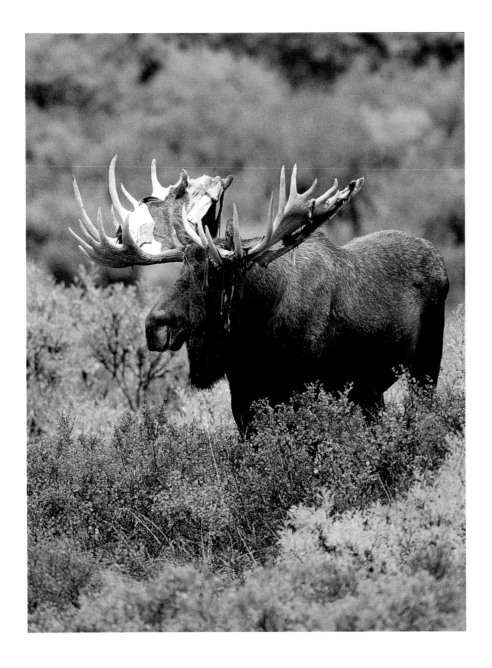

velvet is shed. Bulls will thrash their antlers against bushes, trees, or any hard object, tearing and wearing off the velvet skin. The underside of the skin is moist with blood and the remaining nutrients.

In one encounter, Karen and I were watching a moose slough off his velvet and noticed a wolf watching as well. Later, the wolf retrieved the velvet that the moose left behind on a branch and ate it. That was our first observation of that kind of behavior.

When moose are prompted to cast off their velvet, I imagine they suffer some kind of sensation, almost like an itch that won't go away, because they will thrash the bushes for days to rid themselves of the bloody mess. The freshly scraped antlers will be blood red until the sunlight oxidizes the color to a white or brown. Occasionally a section of velvet will remain for a while on the antler, dangling either in strips or as a sectional patch.

When the shedding begins for the bulls, they slow their feeding behavior and spend most of their time gearing up for herding females and for fights with

This large bull is beginning the process of shedding his velvet; it's late August. The long drape of fur beneath its lower chin is called a dewlap and is characteristically different from one animal to another.

other males. Tyson, the record-size moose, thrashed the willows as if nothing else mattered. The moose ignored us as we filmed and photographed.

Moose are such large animals, with such unique features, that they appear to be a prehistoric remnant from a time when animals were larger and ungainly. Shane said, "This guy is big, but wait till you see Buster—he's even bigger." We couldn't even imagine a showdown between Buster and Tyson.

* ✳ *

Here in one of the most pristine forests we ever had the pleasure to visit, sitting on mounds of moss and lichens soft as a cushion, we made plans for camping out and for filming the fall rut. There were so many moose, both male and female, in this singular spruce forest that we began to call it "Moosewood."

The day quickly closed in on us, and we accepted the weather change and retreated. On the way back, we saw fresh signs of a berry-eating bear. In the middle of

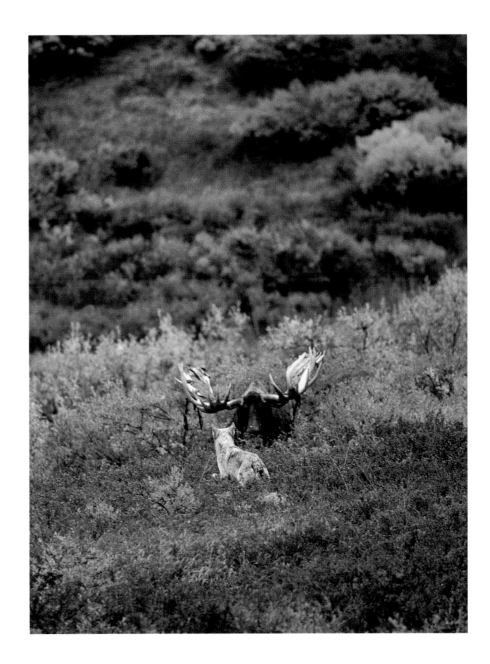

A rare occurrence: a wolf approaching a bull moose as it sloughs its protein-rich velvet. The wolf will eat the velvet left behind in the brush.

One hundred five

the path, the scat was so large you could have tripped over it. It had been quiet up to that point, and we began looking around for more clues. Karen found several tracks pointed toward Moosewood's interior. All of a sudden, there seemed to be new meaning and expectations for our camp during the fall rut.

Karen and I had fall road permits in the park and hoped to cover many miles in search of wild Denali. We had idealized hopes of finding wildlife in the changing color of fall. Finding wildlife in this red-orange foliage with Denali in the background would be a dream of photographic richness and simple, visual splendor.

* ⁕ *

The park road follows a wonderful stretch of habitat, particularly in the high-elevation ridges, passes, and open tundra areas above 3,000 feet. Wildlife frequent these treeless open habitats, and it is easier to spot animals in these clearings. Many abundant foods are available there, such as berries, root tubers, and ground squirrels. Willows line the ravine and creek bottoms. Moose favor the willow leaves and blend in or disappear with ease amid these patches. They can strip a group of bushes in record time, feeding on large quantities of fresh leaves.

Another moose zone (and one of my favorite parts of the park when clear weather brings out the mountain's drama) lies west of Eielson Visitor Center in the kettle-ponds habitat. Huge pieces of remnant ice from retreating glaciers slowly melted over many years, leaving deep impressions that formed the ponds, some of which are the size of small lakes. Beavers make their lodges in many of them, especially the smaller ponds connected with creeks.

An aquatic plant that moose enjoy grows on the bottom of the ponds. Moose use their tall legs to go deep in the pond muck to feed. Sinking their entire head in the water, they retrieve mouthfuls of pond weeds from the bottom and chew them above the water.

Often in this area, and 20 miles farther west along the shores of Wonder Lake, we've observed cow moose teaching their calves how to find and eat the tasty pond weeds. Early one fortunate morning, we woke at 4 a.m. to clear skies. The mountain was out in pinkish alpenglow. We watched and photographed a cow moose with two calves feeding in Wonder Lake against the splendor of Denali. For all practical purposes, we could have been novice photographers that happened across this set of rare variables and took a photograph that would be hailed with kudos. "Beginner's luck," they would call it. For Karen and me, it was finally being in the right place at the right time, a trophy after eight years of watching. It was a lot easier waking Karen up at 4 a.m. after that.

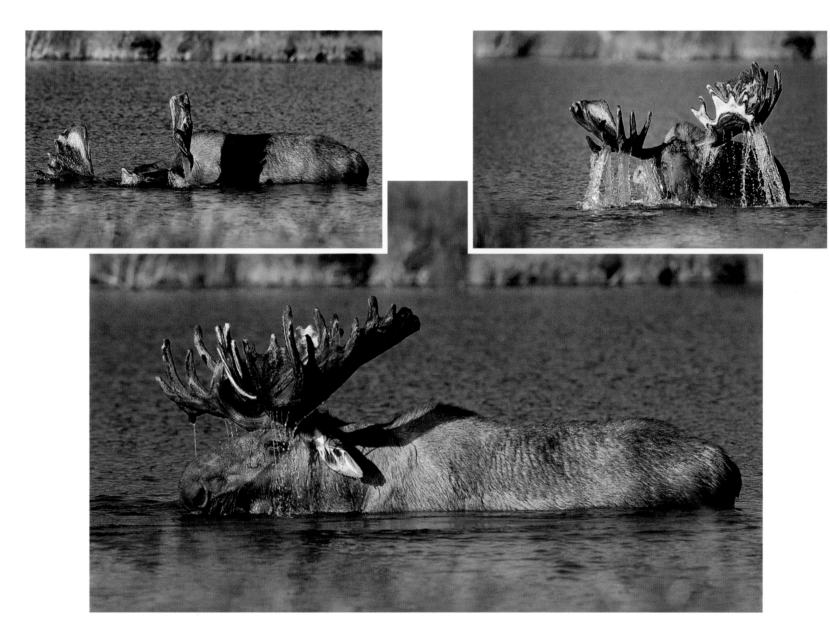

Feeding on aquatic grasses, this bull moose submerges its head completely underwater and tears up a mouthful of vegetation before surfacing above water to chew. The white color of its antlers is a drying process suggesting that the velvet will be shed very soon. The moose rolls back his ears to avoid getting water inside.

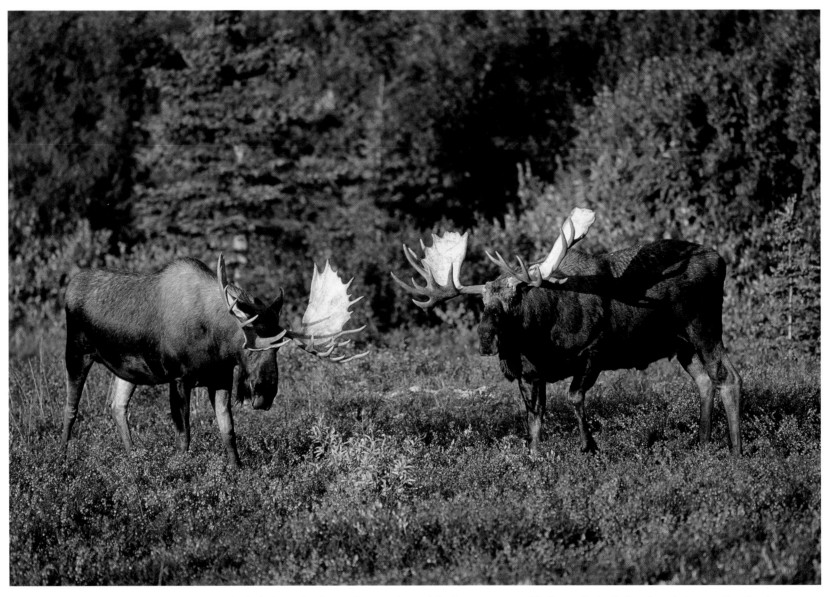

Poised for battle, two large bull moose move slowly, displaying their large antlers in a side-to-side head wag presentation. The "size up," when bulls evaluate their competition, is a slow, patient set of movements and provides a chance for retreat. This process provides a better evaluation of each opponent's size, thus reducing unequal battles. Fights may last 15 to 30 minutes. These two bulls battled for close to 30 minutes, as they are equal-sized competitors.

One hundred eight

* ✱ *

In late September, when it came time to haul in a two-week camp up the Savage River to Moosewood for the rut, Karen was ready. Because of all the camera, camping, and miscellaneous gear, we made two trips. The park was mostly closed because the season had ended in mid-September. The weather was still fairly pleasant, with no accumulated snow. We grunted heavy packs across the Savage River in hip boots, being careful in the deeper sections to keep our footing.

Among a circular group of spruce trees laden with a variegated green mixture of mosses, lichens, and grasses, we set up camp. The spongy ground was ideal for a tent with or without a sleeping pad. We picked out a cooking and eating area far away from our sleeping site. We had not seen any new sign of bear activity, but we remembered the pile of scat earlier in the season and preferred a safe camp. Shane and Lybby, with similar gear, made a camp much like ours. It was a pleasure to be in the backcountry together as a group, combining safety and great camaraderie.

On the second day, we hiked high up on the nearby slopes. This was a good vantage point to begin watching and listening for moose. We could hear the bulls grunt and cows calling back with their guttural mooing sounds. Watching Moosewood, we could see a flash of white

through the green-and-brown forest. Karen and I called large antlers "canoes." Bull moose support headgear measuring 5 to 6 feet wide. A month after shedding their velvet, the sun-bleached antlers sharply contrast with the fading autumn colors. Shane spotted several canoes in an eastern forest and we decided to hike over in that direction. With moose in the area, you need to walk slowly and quietly. With all of our senses on full alert, we slowly hiked as a group.

* ✱ *

What looked to be a short distance visually meant an hour-and-a-half hike on the tundra. When we arrived, Shane signaled there were two huge bull moose ahead: thumb against the side of his head with his palm fanned out in an arc. Could it be Buster and Tyson? Two sets of white canoes flashed through the forest slowly making their way toward us. Karen and I set up tripods near Shane and Lybby and waited quietly. The bulls sized each other up, tilting their antlers from side to side and straining their eyes as they looked each other over. One began thrashing a bush with its antlers, and the other moose joined in on another bush at the edge of the forest.

As this pair of champion-sized moose filled the forest with the sounds of thrashing antlers, they drew ever closer

to each other until they made contact. Antler-to-antler, the sound echoed through the forest. They continued to move their battle in our direction as we photographed through a clearing. As we gorged ourselves in exposed film and the intoxicating experience of Moosewood, we lost contact with all the particulars of our surroundings.

Then Karen startled us with her bird whistle. Shane and I turned around and saw a third bull. He had quite a noteworthy rack and was approaching us quickly, looking bug-eyed. The bull was too close for us to move out of its way. Shane spoke up to the moose, deep and slow, "Youuu beee gooood." The bull moved the spruce bough next to the tree where we stood with his left antler, acknowledging our presence, then continued directly to the other moose.

We looked at each other with startled eyes and eyebrows raised. Shane whispered, "That's Tyson; he's big and ugly," referring to his large face and atypical rack formation. The three bulls thrashed spruce trees and brush, and all continued to push against each other. We photographed for a while in amazement. The group of trees that protected us seemed too small to conceal us from this kind of moving tonnage. Karen again gave her whitecrown sparrow call as a fourth bull pushed his way through the forest.

As the bulls moved into position, we no longer needed long lenses. This was incredible behavior—four huge bulls fighting close together. We excitedly documented the quorum of bulls on film, awaiting the outcome of the titanic battle. Tyson quickly dispatched the smaller-sized bull with a sharp push, causing it to call out in retreat. He then expressed his anger toward the other smaller bull, which only had two brow tines on each rack.

The two-brow bull aggressively pushed at Buster, but the fight didn't last long: in one quick move Buster physically pushed the smaller bull back several yards. Buster continued to push hard, chasing the other bull away. Now, the two smaller bulls circled the area in defeat as our attention was drawn to the two larger bulls. The big bulls moved off and jousted separately.

Buster was a 4x4, meaning he had four brow tines in the front on each side. Tyson was an atypical, with four on one side and an irregular cluster on the other side. If he had not had something happen during velvet formation, he would have easily had five brow tines. The trophy for winning the Moosewood championship was the harem of cows that surrounded the area where the bulls fought. Karen, Shane, and I photographed this Olympic challenge while Lybby recorded sound.

The bulls first touch antlers for a final "size up" and begin to push at each other with tremendous strength. Bulls may weigh up to 1,400 pounds each.

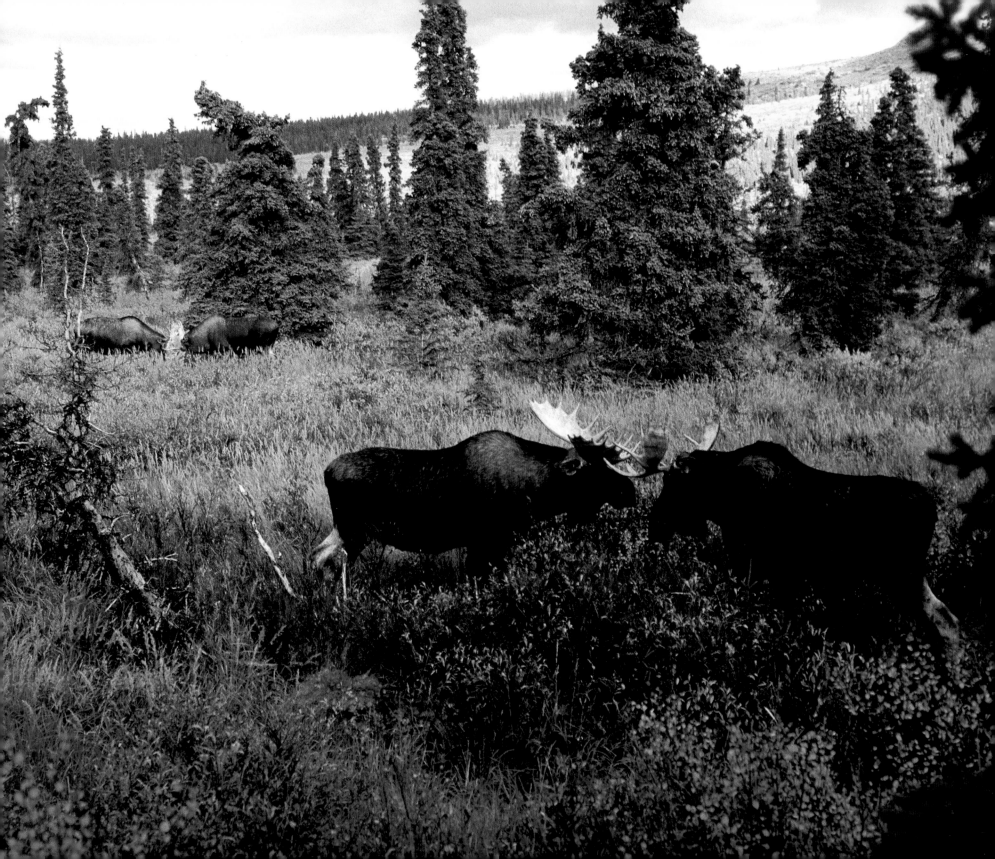

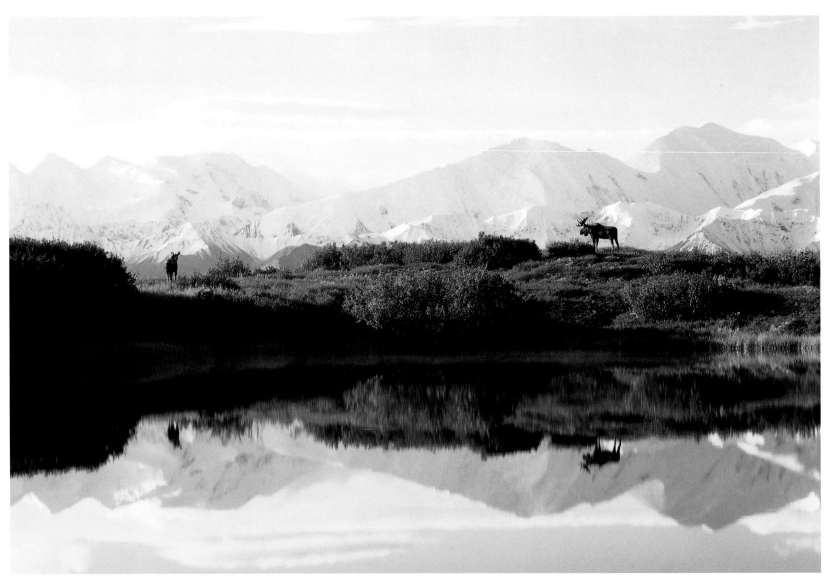

A bull moose follows intently as a cow wanders through the willows and birches of the famous kettle pond, Reflection Pond.
Here shown in a crisp reflection of Denali and the Alaska Range, this landmark is an icon of Denali National Park.

The bullfight went on, the moose oblivious to our presence. Tyson and Buster were almost equal in size, so no bets were placed. At one point in the match, Tyson slipped on his front hoof and went down on that knee. Buster took that opportunity to move in aggressively with his large antlers. The twisted contact caused Tyson's large-palm tines to snap like a green spruce bough. The broken antler dangled, still attached to Tyson by a layer of connective tissue. Tyson might not have been aware that he had broken part of his antler. Any sensitivity there had ceased long before with the shedding of the velvet.

The combination of the fall to his knees and the dominating, tine-breaking move by Buster caused a resurgence in Tyson's competitive spirit. Tyson fought back with the strength of a champion and drove Buster off. As he retreated, Buster looked back, shaking his head from side to side with the strain of his large antlers. He moaned and thrashed brush along his way through an opening until he was out of sight and sound.

During prime autumn days the tundra radiates color. A grand bull moose wandered over to a kettle pond and proceeded to drink in the early morning hours. The bull took time to wade up to its chest in the pond in search of aquatic plants, a favorite delicacy.

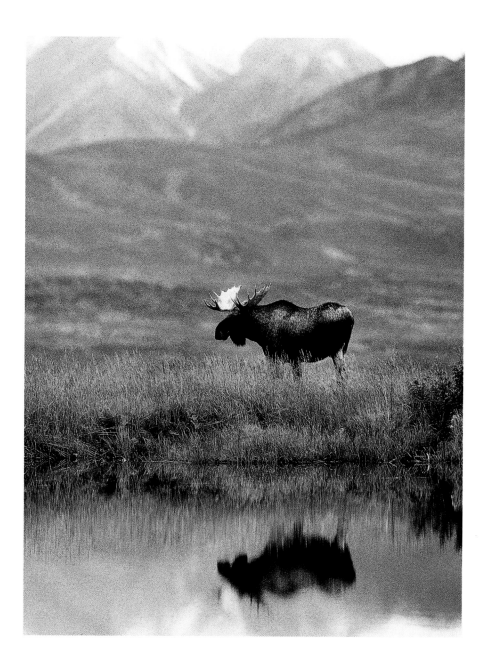

* ❋ *

Sometime later, Shane, Lybby, and Karen and I all followed a bull with a harem in the peak of the rut. Moving back and forth through the harem, the bull kept track of his females. Finally, the bull scraped out a clearing on the ground three or four feet wide with his hoof. Then with his back legs pushed down and spread apart, he urinated into the scraped patch. I was downwind; my nose squinched in displeasure. A clinging smell of musk dominated the area.

The bull began to lie down and roll in the urine mud puddle, but two females moved in before the male had finished. The male moved off slightly, watching as the females battled in the wallow, the name for the urine pit. One female front-kicked the other and bellowed a distinctive "mooooow," a sound that could only be made by a female moose in heat. Lying in the urine pit, the female moose wallowed until she was covered in malodorous mud.

She then moved off, with the bull lip-curling behind her. The lip curl opens the olfactory scent gland, efficiently processing the smells. After executing the odd-looking lip curl, the bull gets sexually excited. The first time I saw a mating, I thought the bull was a beginner or the female wasn't ready, because the exchange was so brief—the male rears up and then back down in one quick movement.

Shane laughed at me when I expressed my disbelief in this unceremonious romance. I was used to bears embracing for forty-five minutes to an hour. Bears are champion love makers—not like moose, with their mere moment of sexual union. As brief as it was, I managed to photograph the mating but I only had time for one photo.

* ❋ *

In late September, the temperature is below freezing more often than above. We expected moisture of one kind or another, just as one gets in a typical Alaska spring, summer, or fall. One morning we woke to 5 degrees F and found our boots frozen solid. I can remember enduring an entire week of frozen boots before morning coffee. To our delight, one morning we woke to a foot of snow. It was pristinely picturesque. We had all talked of observing moose in snow for months, so we hurried through breakfast in the dark.

As we headed out of camp, close to the kitchen-site entrance we found fresh tracks in the snow. A bear had stopped, probably as we prepared breakfast and did our morning chores. The tracks had a more powerful effect than a pot of Shane's strong coffee. We were very alert and surveyed the area with all of our senses. Slowly we

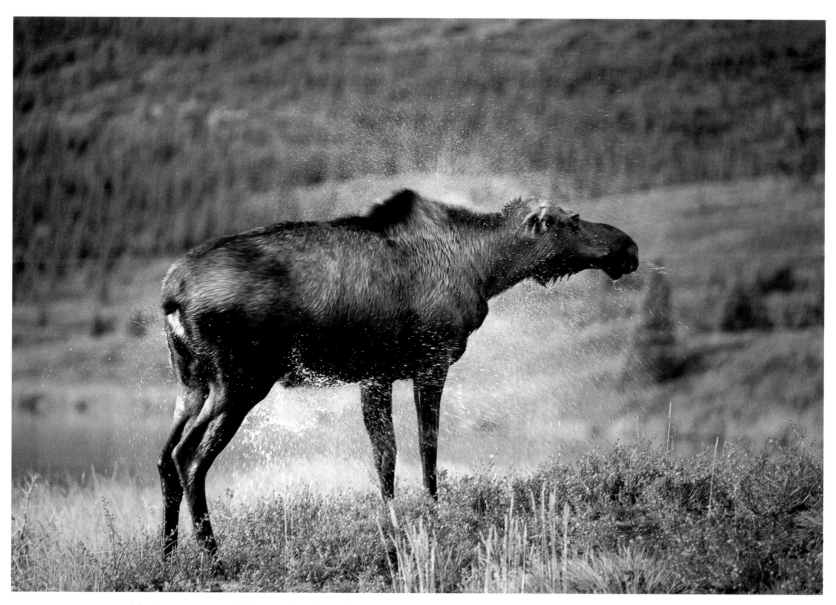

A female moose steps out of the water where she had fed on pond grass. With a quick shiver of her large body, water takes flight in all directions.

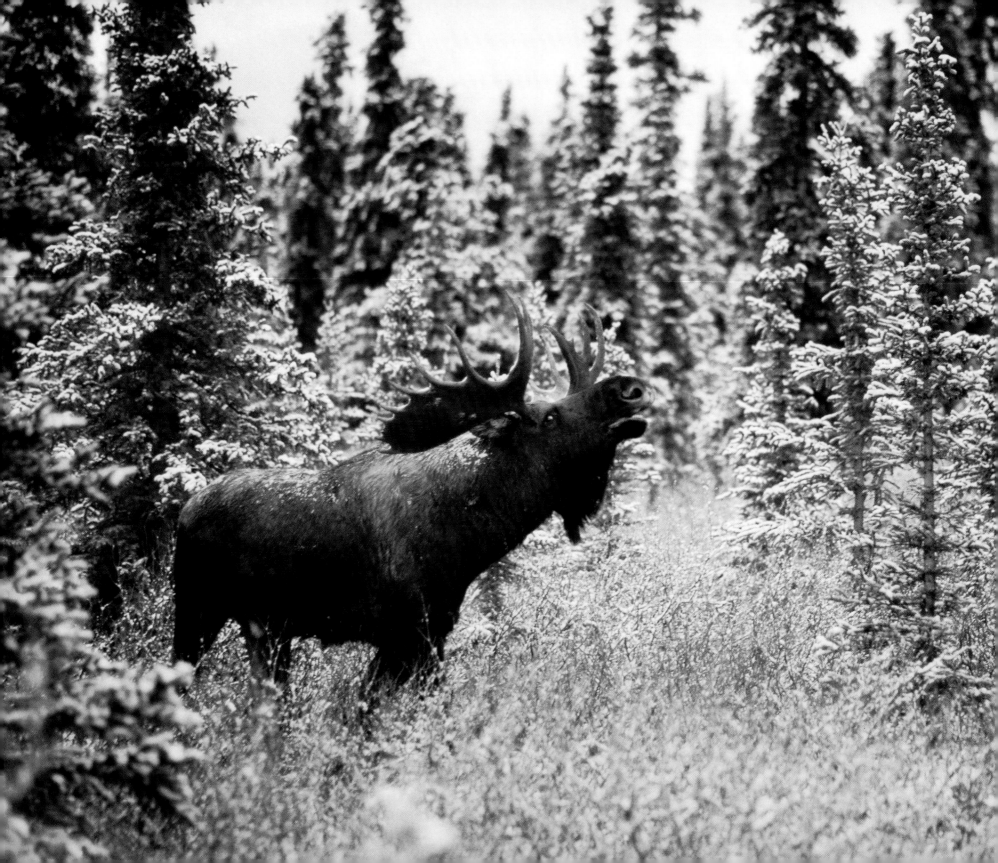

followed the tracks, making noise and discussing variables and strategies. Should we stay and protect camp? Do we follow fresh bear tracks? What about our hopes of seeing moose in snow with early-morning light?

We rechecked all around camp, resecured the food in the bear containers, then headed off in the direction of the tracks. It was still before dawn and the sky was clear. The bear tracks pointed in the same direction as our route to Moosewood. They were so complete we could see where the bear's nose had sniffed in the snow. Then we came across voluminous bear scat consisting mostly of berries. That steamy sign informed us that the bear was close by. We decided to climb high to view the canyon and put our pounding hearts to work. I don't remember who saw it first, but up in Moosewood was a bear moving through the willows. We all sighed and someone remarked, "I hope there aren't two of them!"

We kept an eye on the bear's path far ahead, up Savage River. The bear had passed on the edge of Moosewood and was several miles ahead when we arrived. Moose tracks in the fresh snow accented the familiar grounds, but no moose were around. We set our packs on a rock and spread out to scout, being sure to stay within calling distance of each other as we searched.

Right out of a photographer's dream, the sun rose over the ridge and bathed the new snow in a warm hue. But no moose. Moose tracks led out of the woods and to the northwest. The bear had scared more than just our team. We looked all around Moosewood, but not a moose was to be seen. From a high perch, we scanned the entire surrounding area for white antlers or sounds of the rut. We looked for most of the day with no results.

By early afternoon, Shane and Lybby had decided on Plan B. They needed to charge batteries for the Arrieflex motion camera, and also wanted to check about locating other harems with the moose researchers who were in a closed area several miles to the east. They packed up and quickly headed out.

Sitting at our rock in the center of Moosewood, Karen and I watched them hike off from camp starting the six miles to the road. We looked at each other and summarized our situation.

I said, "There's a bear in the area."

Karen volleyed with, "The moose are gone."

I said, "Our friends are gone."

Karen countered, "But we're not alone, are we?"

A bull moose maintains a harem of females. The male urinates in a wallow then rolls in it using his strong odor, along with grunts and moans, to attract the females.

* ❋ *

The next day was clear and cold, and in the predawn light we decided to hike to a spruce forest over the ridge from our camp. The snow was deeper in the open areas and made travel slow. It was only three miles, but the snow and terrain made it seem much farther. Just as the light of the morning sun shone on the forest floor, we found a moose harem. At first we counted seven females, one with a large calf on the far edge of the harem. The combination of snow and light made for good photographs.

Suddenly, I heard a repeated whistle. With her thumb to her head with the palm up, Karen signaled that she saw a bull moose. There was Buster. He had found his own harem, establishing a second Moosewood. He was sleeping—or, as Karen says, "bull-dozing."

We photographed in Moosewood II most of that day. When Buster finally decided to get up, we marveled again at his size. The females all stirred excitedly when he got around to his morning urination. Karen found herself eye-to-eye with a nervous female and I watched the encounter unfold. The cow moose had been jousted by another cow moose moments before and turned toward Karen in retreat. The female stood on her back legs and kicked out at Karen. I quickly moved directly behind Karen using

Shane's deep, slow, "Youuu beee gooood" line, while simultaneously making three snowballs. I gave one to Karen and immediately threw one, hitting the cow on the nose. Lucky shot for sure! The moose "moooooed" in disappointment, moved left, then right, and finally retreated at a trot.

Karen and I have always said that it's the cow moose that may hurt you. We chuckled and I felt as if I had done something good. Most important, Karen was safe; I reached out and hugged her. Finally relaxing, we were reinvigorated watching the snowy landscape. All I had to say was one word, freedom. This was it: we had it all—our health, adventure, and each other. Another personal summit, courtesy of Denali: the moment of fulfilling a dream, elevated with the freedom of the wilderness.

We had accomplished what we had hoped for and more.

* ❋ *

Shane and Lybby came back three days later with big bars of chocolate and news to share. They had gone into the Jenny Creek closure with the researcher, but all the moose were collared. Shane was frustrated, but glad to hear about our latest encounter with Buster. We found the Tyson harem again the next day. During a midmorning

snack with coffee, we paused at our big rock and watched the canyon. Shane and Lybby's happiness about being back in Moosewood gave another reminder to Karen and me about the freedom of field work.

As we watched from our rock perch, we spotted a wolf halfway to camp. The lead wolf was followed by a second wolf, a third, a fourth, a fifth in line, then a sixth, and, finally, a seventh wolf in the pack, moving through the canyon. Seven summaries of wilderness.

It was obvious from the wolves' tail position which wolf was the leader of the pack. She was a female with tail curled up, in the fifth position in the line. Three young wolves were in the center of the pack, and by their size looked to be spring pups. We watched every step. Occasionally, one or more would be obscured behind a shrub, but others in the pack helped us maintain visual contact. A steady trot moved them in fifteen minutes through the same area that we had hiked in an hour-and-a-half.

The wolf pack crossed the Savage River near our camp and headed toward Moosewood II. They obviously traveled a known route in their home range. We wondered whether the snow had brought about any change in their home range or if this was just a routine patrol. We all thought this group travel by the wolves to be an exit plan toward winter grounds, looking for moose hurt or wounded during the rut to feed upon.

* ☀ *

It was now several days into October, and we too had our exit plan. We had run out of food and relied on Shane and Lybby to augment our last night. We stayed up talking until the northern lights came out. The clear night was cold, but we were compelled to stay out watching in amazement the movement of the aurora borealis. Within the silhouetted trees of Moosewood we all gave quiet thanks for the wonderful nature we had come to live with and learn from.

Clouds began covering the northern lights from the southwest and sent us to our tents about midnight. We woke early the next morning to a full snowstorm. We broke camp quickly in the next moments, in fear of getting snowed in off the park road. My pack weighed close to 100 pounds and Karen's must have been 70. What had taken us two trips to pack in, we had to carry out in one trip, or our vehicle could be stuck all winter. Shane helped me get my pack on and as I lifted his up, I recognized that his was even heavier than mine.

The hike out was brisk and the horizontally blowing snow didn't help. The wind and snow formed a stormy

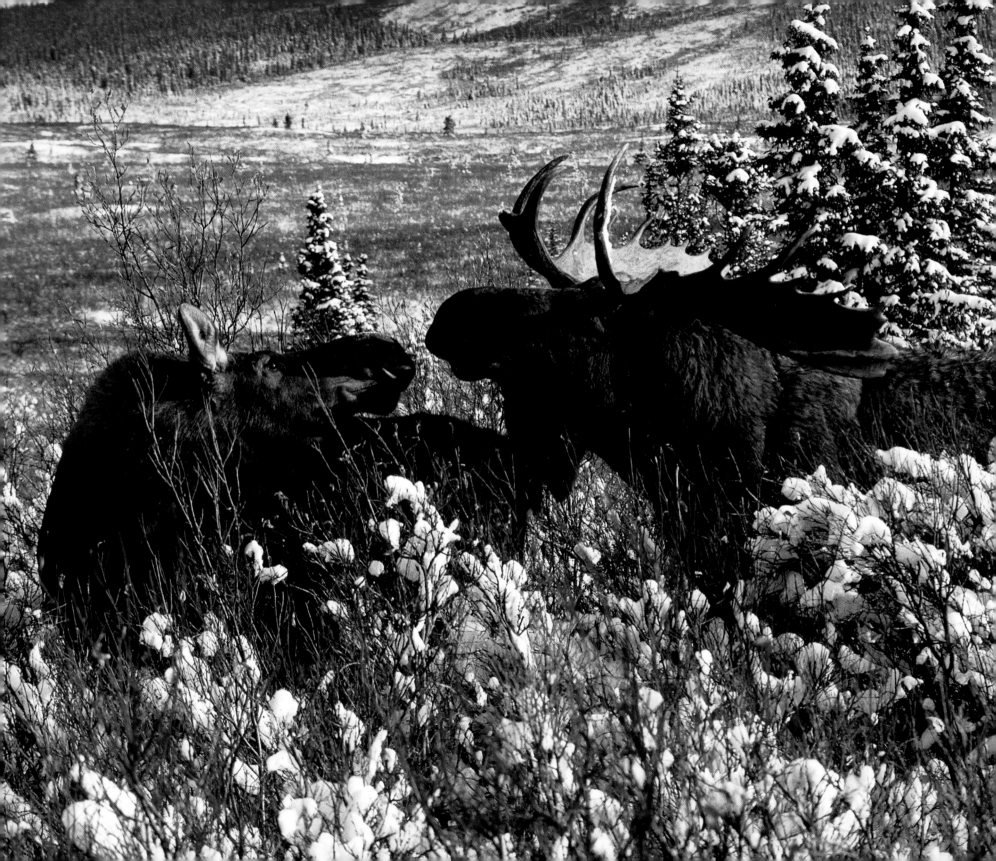

curtain, severely limiting the distance we could see in front of us. The route we had learned over frequent trips was hard to find, let alone to follow. Finally we made it to the river crossing. We switched to our hip boots to wade across. Karen, standing with her heavy pack, slipped on an icy rock and fell forward. I grabbed her pack and comforted her.

As she regained her bearings, I carried her across the river and went back for the packs. Two more crossings and we headed to the vehicles five minutes away. I didn't realize at the time that Karen had hit her head but I could tell that she wasn't feeling her spry self, so I suggested she rest and I went about departure chores, as did Shane and Lybby with their truck. The storm was rapidly piling up snow, so

we moved quickly to begin the drive back to headquarters.

No tracks were on the road, and there were no signs that anyone had been there today. The road was icy with snow, but we made it back safely. The park service had closed the road at the headquarters gate, so we backtracked and followed a service road to exit through the back of headquarters. Rangers told us we were the last people out of the park.

Thoughts of the deep snow and the harsh winter ahead presented a tremendous appreciation for the wild animals and wilderness we had found, enjoyed, and learned from. For many years to come, this area would prove to be an endless education, of marvel and pleasure and exhilaration.

This male and female moose take a moment to "connect" during the fall rut.

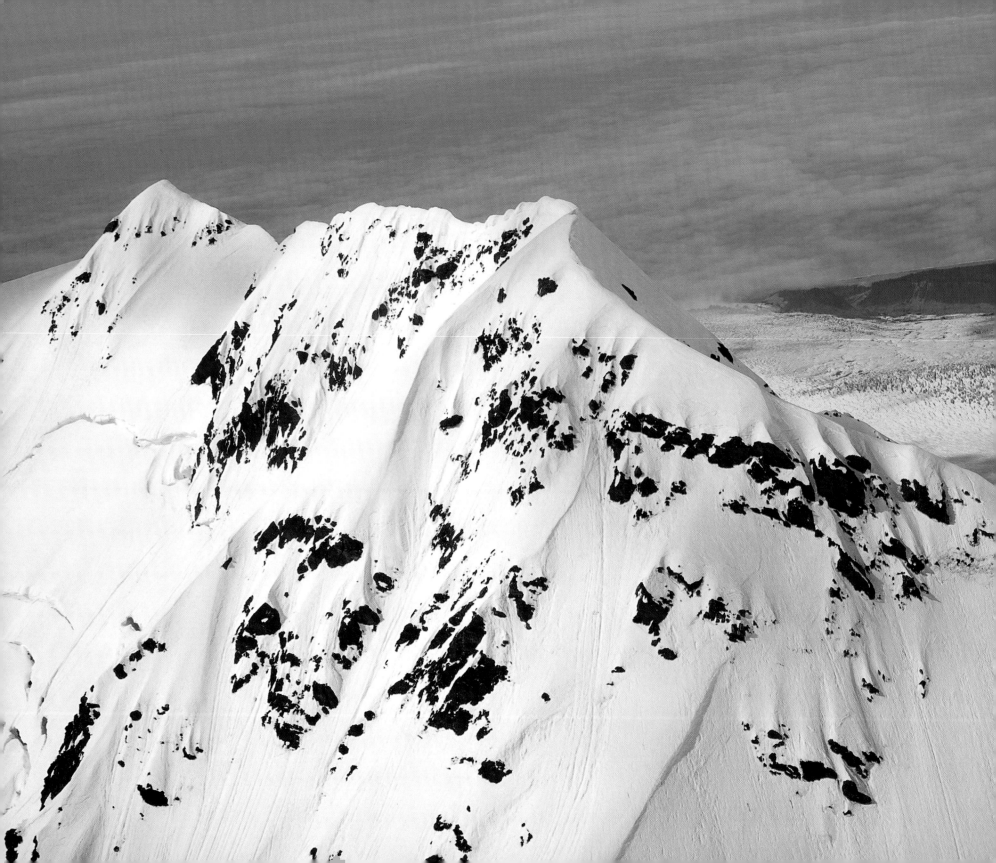

ADVENTURES ON ICE

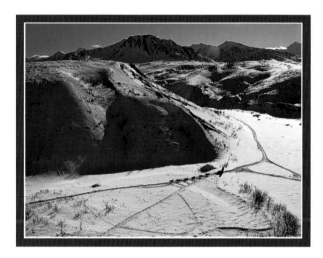

Each year in the winter, spring, summer, or fall, Karen and I return to Denali
for some adventure. For years I have looked out upon the landscape of Denali, conscious
that its winter life has a particularly keen wonder of solitude and snow.

On a cold, clear, winter night the aurora borealis swirls its colors, dancing across the sky. It is so different to see a place year after year during the the summer, then to visit the same familiar tundra and mountains under a thick blanket of winter snow.

As I sat sampling some Wonderberries, looking out over Wonder Lake toward Denali, I remembered what it was like to ski across this large lake in early March. I remembered resting on this same hill and finding a purple-stained snow patch, where I dug frozen blueberries out of the snow. It's funny how a simple taste can bring to mind such wonderful past sensations.

It was only a few months before in 1998 that I followed a sled-dog trail across the middle of the frozen lake. At the south end of the lake was the campground, at the north end a beaver pond, with a side trail that led to the ranger station.

LEFT: High snow-capped ridges of the Alaska Range remain locked in winter year-round. Glaciers form from the annual accumulation of the snow.

ABOVE: A sled-dog team travels along a frozen path deep inside Denali National Park.

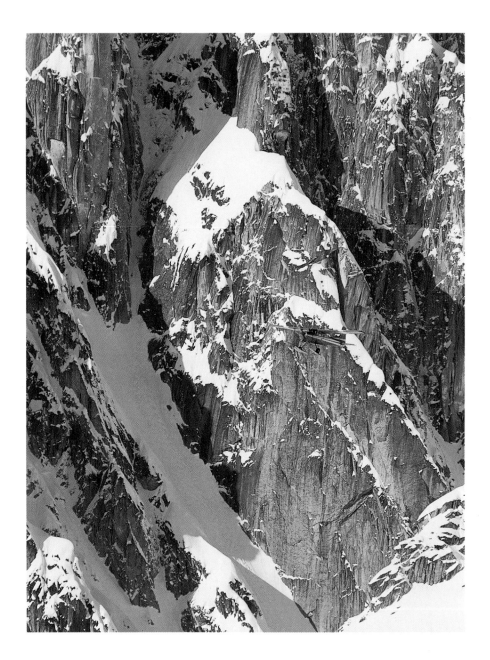

The winter trip was made possible by a joint effort of the Alaska Natural History Association and the National Park Service, a result of my proposal. After nearly a year of deliberation, I was granted permission to ski across the park and join the rangers during their winter patrols. I would provide updated photos for the interpretive branch, while adding a winter perspective to my book project and getting some personal "mountain medicine."

I prepared well for my journey, but stories began surfacing about the dangers of falling into rivers, snowstorms trapping rangers for weeks, and all that can go wrong even with the best winter plans. Of course, you can't anticipate everything. In the couple of days I spent in the headquarters area, three out of four people said they wouldn't do what I was about to do. They told me stories about the hardships of long-distance trips. They spoke of the dangers associated with ski-jouring, which is being pulled behind a team of sled dogs. Those stories were topped off, of course, with all sorts of weather horror stories.

I could have easily listened to the three who wouldn't do it; rather, I looked through the eyes of the fourth. Those eyes knew of adventure's promise and

Small planes, like this one, are the only access to remote glaciers in the Alaska Range.

the reward of mountain medicine beyond the struggle of winter survival. That message is the one I listened to.

On March 1, 1998, we flew out to Kantishna under "severe clear" skies. Viewing the park from the air is always incredible; seeing it under a thick cover of winter snow was amazing. It was rousing to recognize my old haunts transformed by deep snow. Stony Hill had a wolverine's loping tracks and Polychrome emerged in colorful contrast to the snow. Then the mountain came into view, Denali—WOW! Flying above Denali on our way toward the Kantishna airstrip, we followed a sled-dog trail across the center of Wonder Lake. Dennis, the pilot, buzzed the ranger station as we flew by, and started a final approach toward our landing spot, Kantishna.

We landed at a remote airstrip in Kantishna, where a frost-bearded ranger stood guarding his sled dogs. I shook hands with Ranger Gary Koy, who had broken trail from headquarters all the way to Wonder Lake, and we unloaded my gear from the plane. We transferred camping supplies, camera gear, two weeks of food and other survival gear into his sled. I had worn my expedition ski boots and heavy clothing, ready to begin my ski trip.

Winter wildlife sightings are rare. Here, a gray jay appears in the morning as temperatures hover at -25 °F.

One hundred twenty-five

Gary instructed me to head down a trail where he would meet up with me. Before the trip, I had skied for days to train. Too much as it turned out—I had bloody blisters from a pair of expedition ski boots that used to fit perfectly. In my efforts to prepare for the worst, I might have overdone it.

After a mile along the trail I stopped and looked around, breathed deeply, and said to myself, "What a winter paradise!" It was majestic. I stood for a moment, lost in thought, until I heard the sled dogs. For an instant, I felt like the rabbit being chased by greyhounds, my Thoreau moment postponed as I skied on.

The sled dogs and Gary caught up to me in no time and pulled alongside of me. I remarked how striking it all was. These are views that have no price tag. He chuckled and said, "Wait until you see the mountains out! Ever ski-joured?"

"Ah, em, eee . . ."

He interrupted, "Put your ski poles through this webbing, hold your arms out straight and try bending your knees."

"Great," I replied. I was game.

Gary added, "The dogs start out fast, so get ready."

Woooow! and off we went like a rocket. I've skied pinhead-style since moving out west, but nothing had prepared me for being towed by nine dogs.

After the initial fast break, the dogs settled into a steady pace, except downhill and on corners, where the time delay between them so far out in front and me twenty or thirty feet behind the sled on a tow rope made a brief speed imbalance. Nonetheless, it was a hoot, and a euphoric warm feeling contrasted the wind chill on my face. The snowy landscape was captivating.

Unfortunately, ski-jouring requires full attention, and as soon as I turned to take in the whole scene, I was face-down in the snow, my nose next to some poop. "Brown Klister," they call it: sticks to your skis like nothing else in the cold outdoors, something warm that quickly cools. Not quite a rose.

"Whewwww, what do you feed them?!" I asked.

Gary casually responded, "Oh, a mixture of fat and kibble. You'll see."

Bends and turns in the trail remain fresh in my mind. Not only did the dogs speed up as they finished the turn (which was before I *began* the turn), but the nearby willows slapped at me, or reached out to trip me. I'd say we traveled an average of five or six miles per hour. I fell several times, laughing. Whatever I hurt was immediately iced or already cold, so I really didn't feel any pain. We traveled through the drainage up Moose Creek, stopping to photograph. Gary was patient with my enthusiasm. The winter beauty was timeless.

One of the oldest roadhouses in the mining town of Kantishna,
this cabin rarely sees visitors, as it is nearly 90 miles from the entrance of the park.

One hundred twenty-seven

After a half hour of traveling and photographing, we arrived at the Moose Creek junction, alongside the Kantishna Roadhouse. Gary tied up the lead dog and support lines and hitched the rest of the dogs next to the willows. After anchoring the sled and rolling it onto its side, we hiked up to the cabin, falling up to our hips in crusty snow. The caretaker, Mike Weber, waved a hello and waited for us to make our lumbering way up.

He welcomed us into his cabin, while Jenny, his wife, was busy in the kitchen portion of its two rooms. I hadn't expected such a quick and warm social exchange. I learned how they'd packed in all their winter gear last September and planned to stay through May. The winter had been quiet; we were the first of the spring visitors.

Hot vegetable soup and homemade bread were served and eaten with zeal. What a surprising day of adventure and delights! Another special park experience: a good, hot meal, in a cozy cabin in Kantishna at the far end of Denali, in winter. We toured the lodge and photographed the original miner's roadhouse. After an extended session of warm hospitality, Gary and I were off toward the ranger station.

"Great meal!" I exclaimed to Gary.

"Yeah, Jenny is a great cook, but don't get used to it. The rest of the trip won't be like this."

I was warned about his cooking—apparently, the dogs ate better than he did. However, on two occasions he surpassed his reputation and fixed a much-appreciated meal. I didn't see the meals he fixed in my absence, but what I did see was an elaborate feeding schedule for the dogs. There was an endless list of chores, including the constant routine of melting snow for water, soaking dog kibble, melting fat globs, and of course, the unrelenting poop scooping. Gary's favorite saying is "Dog poop is my bread and butter."

* ❋ *

An old personal rule of mine is, if the mountain is out, start looking for subjects! So after shuffling gear and cameras, I donned my skis to explore for photographic subjects. The sled-dog ski-jouring let me feel some muscles I hadn't noticed before, so I didn't go far. Actually, I didn't have far to go, as the mountain was spectacular from a nearby ridge. It was almost too good to be true. I hardly ever get what I call "first-quarter luck." That is, it seems I usually have to work the whole game until the last minutes of an expedition to get the photograph that scores.

The snow scenes were so perfect, every scanned vista was a deep reward. The only evidence of man was a sled trail. I breathed deep as I took in the Alaska Range. It had been a long travel from the beaches of Santa Cruz to Wonder Lake. Maybe it is these kinds of contrasts that

afford unsuspected visions or insights. If I watched the winter from the front country of Denali or Fairbanks, maybe I would take snow scenes for granted. Here, every step and every camera composition brought me an invigorating and refreshing setting.

Ranger Gary needed to break trail to the Moose Creek Patrol Cabin, so the next day we traveled north to Kantishna, then east and south following the creek. Breaking trail was much work for the dogs and for Gary. In the deep snow, Gary would snowshoe a trail. Other times I would ski ahead, locating a route and encouraging the dog team in a forward direction.

My reconnaissance was a chance for exploration and discovering tracks. Moose, fox, and wolf had all left footprints along a trail. The best set of tracks was a long, smooth pathway sliding downhill. Some animal was having a lot of fun. At the end of the slide I found webbed toe tracks, sign of a river otter. In my mind I could visualize a ball of energy sliding down and along a steep trail all for the fun of it—again and again.

Especially numerous were the tracks of the snowshoe hare. We saw no other human tracks or sign of disturbance. I made trail all day in the deep snow and photographed in the unchanged clear weather. The sun warmed my body, but the air was frosting my facial hair. On the way back the creek had opened up and now flowed

wider. On the other side was a trail of ice: the water continually flowed over the ice making even more ice, a phenomenon called *aufeis*.

Skiing across the creek, I slipped into calf-deep water and my boots iced solid. As I climbed out from the creek drainage I fell backward. Stunned, with the wind knocked out of me, I lay there for a few moments to catch my breath. Gary and the dogs had taken a higher route. We had been separated on and off for most of the day. My fall was a hard one, but I was determined to catch up to a rendezvous spot near the seasonally abandoned North Face Lodge, so I trekked forward. I tried to knock the external ice off my boots, but the water had seeped through gaiters, ski pants, boots, and two pairs of socks. I could feel my feet tightening and constricting as the water froze around them.

Another creek crossing was wider still, flowing at knee level. I hopped with skis in hand across the 25-foot-wide creek to the icy banks. To cross the stream turned out to be a mistake, but with no other way to get across with my skis on the iced edges, it seemed the right decision. But I had analyzed the creek wrong; it was even deeper than when I crossed it in the morning. It was getting dark when finally I caught up to Gary and the dogs, and he indicated that we needed to get going.

Back at the road, I ski-joured behind Gary toward the Wonder Lake ranger cabin. By the time we arrived at the

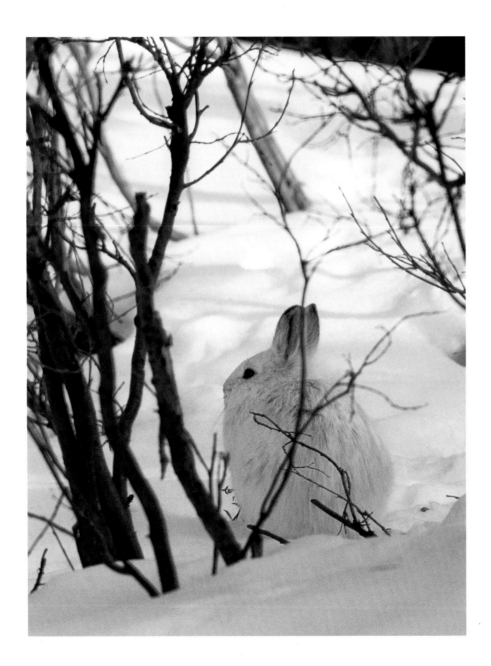

north end of Wonder Lake, I could not move my toes. I let go of the tow webbing and tried skiing to work warmth down to my feet. Gary suggested we stay on the road to get back to the station faster instead of taking the trail down to the lake.

When we arrived, my feet had evolved from numb to pinprick-tingling, with a deeply constricted, compacted pain. Gary relieved me of chores so that I could go warm my feet. The removal of many layers of pants, gaiters, boots, and socks revealed whitish-blue iced feet. One boot was filled with ice, contoured to the impression of my foot. But I was soon to forget my feet when I saw the mountain in alpenglow.

I donned my down booties and grabbed camera gear to head out to the ridge nearby. I set up a tripod while the mountain luminesced with a pink hue, splendidly contrasting with the even white of the horizon-to-horizon snow. This was all the mountain medicine I needed. (The two hand-warmers I slipped from my camera case into my booties helped also!) I watched the mountain long after the alpenglow had left, as if I expected Denali to disappear, as it so often

A snowshoe hare is almost completely camouflaged in its winter white coat. It prefers willow thickets and uses its own trails night after night to find twigs and leaves still edible above the snow level.

afford unsuspected visions or insights. If I watched the winter from the front country of Denali or Fairbanks, maybe I would take snow scenes for granted. Here, every step and every camera composition brought me an invigorating and refreshing setting.

Ranger Gary needed to break trail to the Moose Creek Patrol Cabin, so the next day we traveled north to Kantishna, then east and south following the creek. Breaking trail was much work for the dogs and for Gary. In the deep snow, Gary would snowshoe a trail. Other times I would ski ahead, locating a route and encouraging the dog team in a forward direction.

My reconnaissance was a chance for exploration and discovering tracks. Moose, fox, and wolf had all left footprints along a trail. The best set of tracks was a long, smooth pathway sliding downhill. Some animal was having a lot of fun. At the end of the slide I found webbed toe tracks, sign of a river otter. In my mind I could visualize a ball of energy sliding down and along a steep trail all for the fun of it—again and again.

Especially numerous were the tracks of the snowshoe hare. We saw no other human tracks or sign of disturbance. I made trail all day in the deep snow and photographed in the unchanged clear weather. The sun warmed my body, but the air was frosting my facial hair. On the way back the creek had opened up and now flowed

wider. On the other side was a trail of ice: the water continually flowed over the ice making even more ice, a phenomenon called *aufeis.*

Skiing across the creek, I slipped into calf-deep water and my boots iced solid. As I climbed out from the creek drainage I fell backward. Stunned, with the wind knocked out of me, I lay there for a few moments to catch my breath. Gary and the dogs had taken a higher route. We had been separated on and off for most of the day. My fall was a hard one, but I was determined to catch up to a rendezvous spot near the seasonally abandoned North Face Lodge, so I trekked forward. I tried to knock the external ice off my boots, but the water had seeped through gaiters, ski pants, boots, and two pairs of socks. I could feel my feet tightening and constricting as the water froze around them.

Another creek crossing was wider still, flowing at knee level. I hopped with skis in hand across the 25-foot-wide creek to the icy banks. To cross the stream turned out to be a mistake, but with no other way to get across with my skis on the iced edges, it seemed the right decision. But I had analyzed the creek wrong; it was even deeper than when I crossed it in the morning. It was getting dark when finally I caught up to Gary and the dogs, and he indicated that we needed to get going.

Back at the road, I ski-joured behind Gary toward the Wonder Lake ranger cabin. By the time we arrived at the

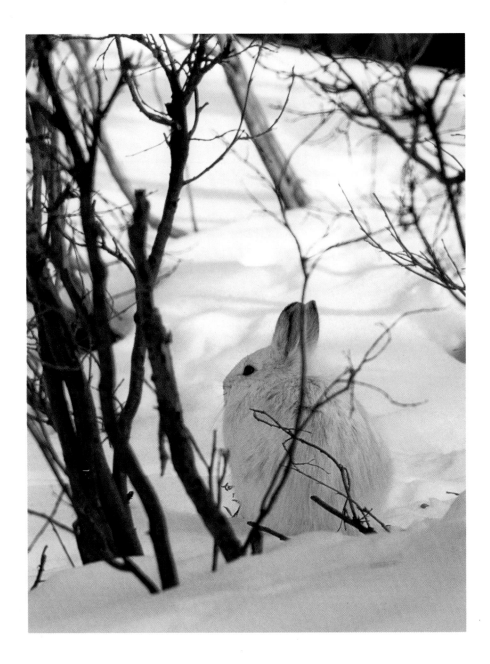

north end of Wonder Lake, I could not move my toes. I let go of the tow webbing and tried skiing to work warmth down to my feet. Gary suggested we stay on the road to get back to the station faster instead of taking the trail down to the lake.

When we arrived, my feet had evolved from numb to pinprick-tingling, with a deeply constricted, compacted pain. Gary relieved me of chores so that I could go warm my feet. The removal of many layers of pants, gaiters, boots, and socks revealed whitish-blue iced feet. One boot was filled with ice, contoured to the impression of my foot. But I was soon to forget my feet when I saw the mountain in alpenglow.

I donned my down booties and grabbed camera gear to head out to the ridge nearby. I set up a tripod while the mountain luminesced with a pink hue, splendidly contrasting with the even white of the horizon-to-horizon snow. This was all the mountain medicine I needed. (The two hand-warmers I slipped from my camera case into my booties helped also!) I watched the mountain long after the alpenglow had left, as if I expected Denali to disappear, as it so often

A snowshoe hare is almost completely camouflaged in its winter white coat. It prefers willow thickets and uses its own trails night after night to find twigs and leaves still edible above the snow level.

does, into the clouds.

The dogs kept Gary busy, more than I would have imagined. It didn't take long for a couple of the dogs to become my favorites. Some were afraid of me no matter how patient I was with them, while others begged for a little rough play, or any touch.

The next day was a day off for the dogs. Gary caught up on chores and I explored the area and set up spike camps. I placed one Arctic Oven tent near the ranger station, and a North Face mountaineering tent beneath Denali for a view of northern lights, if they came. I slept in the Arctic Oven tent and it kept the moisture off my sleeping bag, but it was anything but an oven.

Cold can relieve sore muscles, but by morning I was stiff from a deep-to-the-bone cold. Once again the day began with an incredible magenta alpenglow, so I quickly forgot the discomfort and was up a hill for another great Denali landscape. This was the fifth day in a row of clear weather. I treated each as if it would be the only clear day. Odds were it would be the last.

The sled dog team followed a river that had recently overflowed with newly formed ice. This slippery surface is treacherous to our movements, although sled dogs move across with little change in pace. At times, you can hear the sound of the river flowing underneath you.

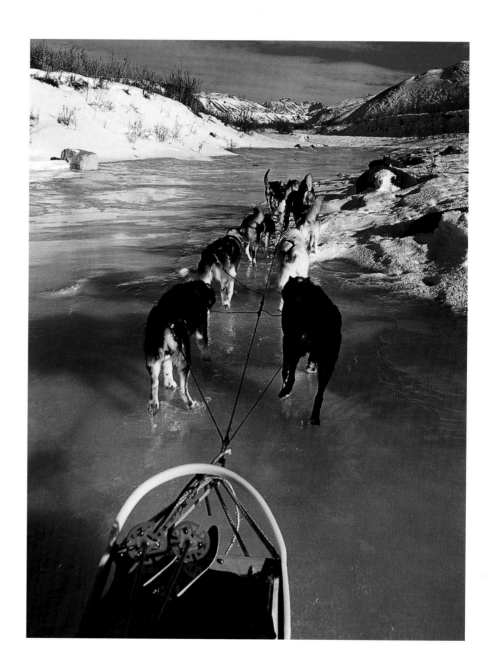

One hundred thirty-one

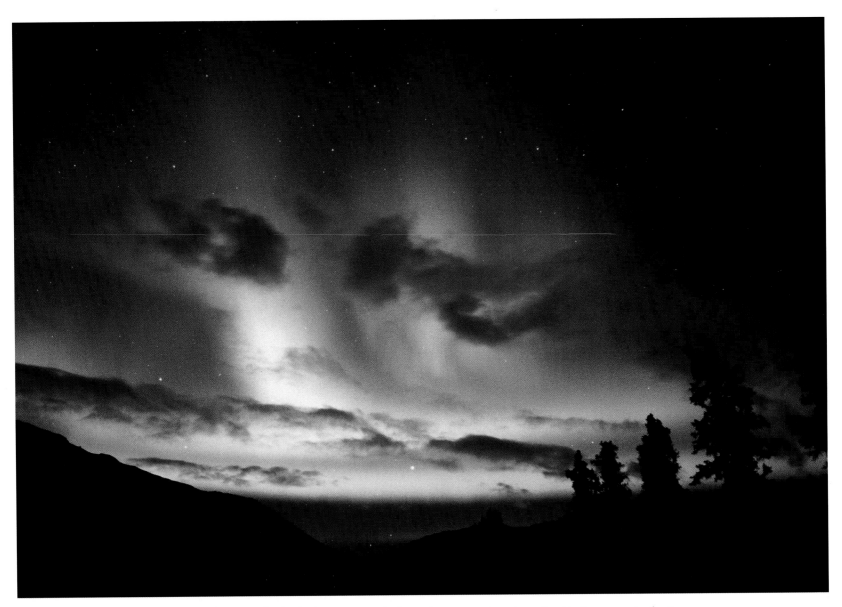

Northern lights are a reminder that this is an uncommon landscape. Amazement and wonder are found in the movement and patterns.
The combination of a few clouds adds to the dimensionality of this midnight phenomena.

It was hard to imagine leaving the Wonder Lake area with all the great weather and tremendous views of Denali. But Gary had been at Wonder Lake for two weeks and missed his family. And we still had at least four days to complete the journey back to headquarters. If all went well, the fastest return time was three days, and recently it had taken as long as ten days. These could be the kind of trips upon which legends were built.

* ✱ *

But other legendary events first: I stayed up into the early morning before our return trip, watching a spectacular aurora borealis display. That night, I'd bedded down after having looked for lights. I drank a thermos of water to guarantee a wake-up light-check later in the night. No less than ten minutes after I had zipped my sleeping bag, Gary returned from checking the dogs to announce the lights. Their intensity was riveting, particularly under the light from an almost-full moon.

In the eastern sky, a green arc was fringed with crimson pink in waves of light. Strange folds and swirls patterned the line of the sky. The dogs howled as the lights reached the greatest intensity. Seeing the lights again reminded me of every time I had enjoyed watching them. I was again awestruck at the colors. I don't care if you've seen them a hundred times, they still stop you in your tracks.

Watching the lights is an experience that doesn't quickly fade. As I looked at the mountain, thoughts swirled in my mind about primitive people viewing the same lights, people who perhaps wondered what the gods were communicating to them. For me, watching the lights is a treat, but I imagined early man being frightened by the building intensity and patterned movements of the lights. With all our knowledge of science, we still know very little about auroras. The swirls make recognizable shapes—or omens—and many things could be read into them. Or you can just lose yourself in awe. To me, they are a miracle of nature.

* ✱ *

At daybreak, Gary and I were off on our return trip. I skied out ahead enjoying the solitude. It was hard to look down at my skis as I crossed Wonder Lake—directly in front of me was a full-scale view of Denali. Gary and his sled-dog team caught up with me at the south end of Wonder Lake, just in time for me to catch a ride uphill. The trail led through the entrance to the campground and up over a ridge looking down onto the McKinley River Bar. I let go at the top and enjoyed a downhill ski through the trees. The narrow trail was flanked by spruce trees that reached out and touched me as I passed.

I hit the long straightaway, then a tight curve with no room to snowplow-brake. There was not even enough room to plant a pole. I lifted the inside ski at the apex of the curve and skated around the curve. Shifting my weight to the inside and lifting my outside ski, I made a complete turn without slowing down, all in one motion. I allowed the weight of each ski to make the turn. I had learned this by falling too many times. After a week of falling, I was now determined to stay up.

Skiing through the forest to the McKinley Bar was one of the most memorable parts of the route: a bit of an out-of-control "YAHOO!" experience, but exhilarating nonetheless. This forest is one of the largest, longest forests in Denali.

When we arrived at the river bar it was treeless and wide open. Water had recently flooded over the top of the blue-colored ice, which reflected the beautiful landscape and sky like a mirror. My biggest fear in preparation for this trip was the dreaded McKinley Bar winds, which build to bone-chilling extremes. This razoring wind chill, mixed with cold temperatures, could only be compared to what I had experienced in Siberia, Russia, several winters earlier.

Feather crystals are a pattern of snow and ice found on rivers formed along open breaks. Large examples are about 4 to 6 inches long.

Thankfully there was no real wind to speak of, just an occasional micro-climate shift in the air, but otherwise perfect. At any moment, I expected the weather to change. Alaska weather seems to change so quickly, especially at Denali, where the mountain creates its own weather.

The river bar was mainly covered by ice, but there were open sections where water flowed rapidly. You could hear the water gurgling beneath the ice. Feather crystals formed along the edges from the leads of open water. Throughout the river bar, wolf tracks were more noticeable than in the other areas we had patrolled. It was obvious the wolves used the same drainages and natural routes of travel that we did. The tracks told a travel tale of a wolf pack and their back-and-forth movements on this trail. We traveled parallel to the course of the wolves since it was obviously an easier route.

Seeing tracks of wolves, caribou, moose, fox, wolverine, and many other animals along the bar helped me understand winter and summer wildlife movement better. For years during summer, I had watched wildlife disappear along a fold in the landscape. Now I was traveling in those same hidden folds.

The river flowed over the ice in many sections causing a smooth, glass-like surface. Even with metal-edged skis, I was unable to push off to ski properly. I used poles to pull my way across the aufeis river. The dogs moved across

unaffected, while even with the gripper brake on, the sled was sliding all over. Watching the sled dogs move so evenly across the ice gave me a reasonable indication of how easily wolves moved through this iced river valley.

We made it to the toe of the Muldrow Glacier and moved upstream into the folds that led north and parallel to the glacier. In a narrow 200-foot-deep canyon at a "Y" was the Thorofare Cabin. Up out of the canyon was a new cabin (with a bench and a view of Denali). The old cabin had been closer to the McKinley Thorofare River Bar, and as the braids of the river changed course, it had filled the cabin with sediment.

After chores, I took a tripod and camera gear up a ridge for a better view of Denali at sunset. The full moon rose in the east as I watched south to Denali—yet another piercingly clear alpenglow sunset. The cabin's location directed me to think of all the winter patrols over the past century. The view added to the overall peaceful reflection; I found a moment of connection and common adventure with those who had been there before, as if we all were sharing the view and wilderness together.

The evening routine of drinking two liters of water before bed gave me no alternative but to get up and go outside. Thus prompted, I walked past the dogs, petting my favorites, Teal and Shadow. I searched the north sky for an aurora display. In a startling moment the dogs

began howling—one, two, then quickly adding up to all the dogs in chorus. Some of them still were curled up in their sleeping positions while others sat up, muzzle to the sky. Immediately I started talking, saying aloud, "It's only me," and I went back to my favorite dogs and rubbed their heads. My attempts to soothe the dogs didn't cause a break in the howls.

Then in unison, their howling abruptly ended and I heard a wolf howling from the direction of the McKinley Bar. Another wolf and still another joined the first one, in harmony. It was so incredible to be looking toward Denali in the moonlight and knowing wild wolves patrolled where we had been several hours earlier—I got goose bumps. Then the sled dogs started up their night music again, ending sharply after a minute or so. The wolves had moved closer and I heard them again, louder; it sounded as if they were directly in front of me.

The volley of howls between the dogs and wolves went on three or four times, then the night abruptly returned to silence. Every time I heard the dogs howl after that, I contemplated that a wild animal might be off in the wilderness calling back in some form of communication.

* ✳ *

The next day we woke early and Gary fed the dogs warm mush before dawn. I photographed the sunrise, another beautiful clear morning. Instead of heading out first, I stayed behind to photograph the sled-dog team in the canyon from above. I then skied and caught up to them as they began an uphill section toward Eielson Bluffs. We stayed beneath the road in the folds of a wildlife corridor. Wolf, caribou, moose, and several different small animal tracks filled the natural trail.

The day was clear and pleasant giving me the luxury of easy ski-jouring. It was nearly impossible to look around for any length of time, as my complete attention to the terrain was necessary to stay upright. It ran true more often than not that when one dog pooped they all pooped, leaving pungent brown landmines. If I didn't shift my weight and skis to avoid contact, it would stick and freeze in place on the bottom of my skis causing me to fall face-first into more poop. This is a lesson you learn once. Therefore, I paid attention at all times when I ski-joured.

Gary told me he hadn't ski-joured much, and that few people had skied through the park. Where the snow pack was hard, I had a little fun skiing off to the side, almost catching up to the sled, as the dogs would look to the side at me. The dogs were a captive audience to some light-hearted fun. I slalomed one side to the other as if water-skiing. Gary tried to ignore me, but the dogs, especially my buddies, seemed to want to play and pulled the team out of place toward me. Twice I got a discouraging look from Gary, so I left the fun to trail behind the sled.

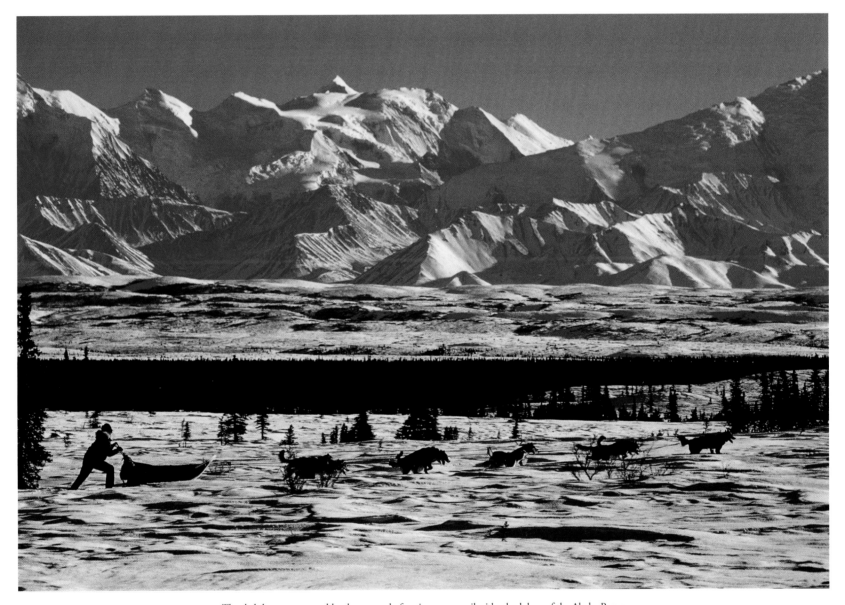

The sled dogs maneuvered hard snow pack, forming a new trail with a backdrop of the Alaska Range.
This traditional means of transportation maintains the quiet, peaceful, and ecological traditions of the park.

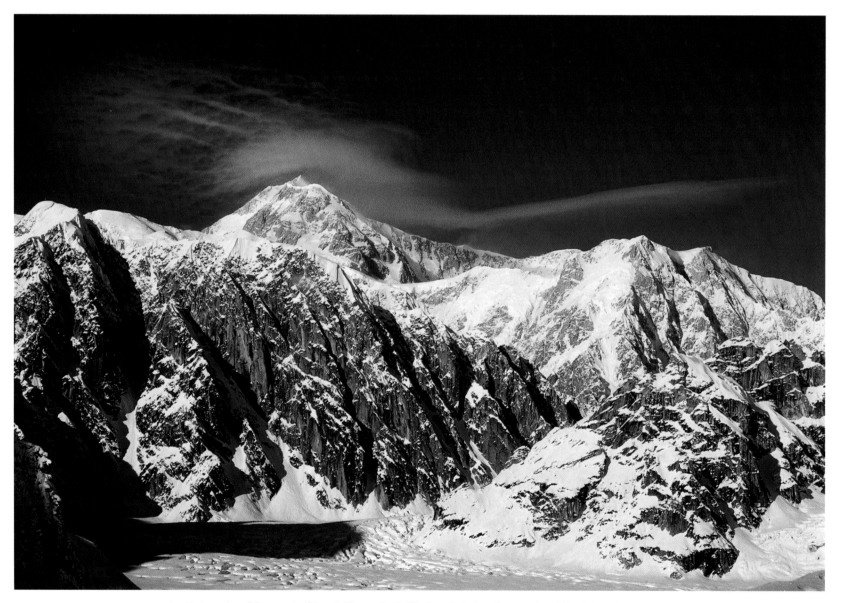

A midwinter view of the summit of Denali. The weather builds along the high peaks as winds and clouds form along its crest.

If he only knew what had gone on behind him, he would laugh in his chair reading this. If he knew how many bruises I had, he might even feel sorry for me. If he knew how many lenses and cameras went in for repair after the trip, he would have flipped. To the rangers, I was just a crazy photographer having fun. After all what else *could* I be doing during this fine adventure? The days had been clear, the mountain was out, and I was on an escapade. It was a time that demanded full, willing, and unregretted participation.

Soon I found myself on top of Stony Hill watching the sled team ride its fully engaged brake at high speed down the steep incline, with snow spraying behind. Gary had coiled huge chains along the runners, a braking method called rough-locking, to slow the sled. Still, as the sled descended, it appeared out of control on the icy, steep terrain. Watching him shift sideways, nearly tipping over to one side, and then seeing the sled swing to near-collapse the other way, I saw him demonstrate his experience and skill by not losing his sled load. Then it was my turn to go down the hill—on skis.

I looked at my old Alaska haunt differently at that moment. In my youth I dreamed of such conditions, but now I prayed that my knees would not fail me. The top of the hill was covered with ice-coated snow. The blowing wind had creased and polished the snow, causing extreme conditions. I felt as if I was in an out-of-control Olympic ski race as I shaved the snow-ice into a turn to slow down. Weaving back and forth with pole plants through out-of-control telemark turns, I struggled to stay upright.

I moved into excellent powder and dropped three-quarters of the way to my knees. The powder broke the speed—ideal conditions. A couple of quick shifts in weight downhill and for a short-lived moment I felt in control. Then I moved onto a narrow shelf with an icy snow layer on top and deep powder below, which caused my skis to submarine. My thighs, knees, and shins cracked the ice above as I continued to sink. I fell in a convoluted, head-downhill position, buried in snow. As I crawled out of the deep snowpile, I realized I was still most of the way up the hill. Climbing back up on the ice, I started another fast run.

I "WAAHOOOED!" as I free-fell, lacking even the most basic control. I had not seen the lip of an oncoming terrace and went no less than twenty feet airborne. Falling to my butt on the back of my skis caused me to go even faster. After a struggle, I managed to get up and make a turn on the next terrace, but went free-falling again, though not as high or as long. This time I fell sideways, but landed upright heading downhill even *FASTER*. I surrendered to the hill and ended up at the bottom of Wolf Creek laughing and hooting.

That was the fastest skiing I had done in a long time, and I hadn't even broken anything, except my personal speed limit. Covered with snow, I looked back at Stony Hill in grand respect. For me, this was a thrill to talk about for days.

* ✳ *

The view from the top of Stony was my last full view of Denali Mountain. We now headed east toward the entrance to the park and headquarters. We still had at least three more days and three nights until we would arrive at headquarters. Toklat, Igloo and Sanctuary were our last three stops, weather permitting. It would be sad not to be able to see the mountain, for it had become the focus of the expedition. From here, we would only see the top of Denali from Sable Pass, then again at mile 10, near the end of the trip. But there were still adventure and obstacles ahead on the trail.

We followed a west tributary of the Toklat River out of Highway Pass into the Toklat River Bar, losing elevation from about 4,000 feet to 3,000 feet. The skiing was gradual and the weather was clear and cold. Ptarmigans graced the willows in full white plumage, their bright-red eye patch glistening in contrast. The avian life was our only wildlife contact, other than tracks in the snow or sounds from the wolves. Gray jays, ravens, and ptarmigans made up the majority of sightings. Skiing up into the Toklat Road

Camp, I saw signs of a golden eagle: snowshoe hare tracks led up to a wing-print in the snow, there with a touch of fur and blood. Perhaps a clue from a successful predator leaving its hunting story in an imprint in the snow.

We started off late the next morning, since the distance to the East Fork cabin for lunch and then into the Igloo Cabin to camp overnight was only twenty miles. The East Fork was where Adolph Murie built his cabin while he studied the wildlife. He significantly added to the understanding of animal population cycles, behavior, and habitat. To get to his cabin at the western end of Sable Pass we needed to travel beneath Polychrome Pass. The winter trail is to the south and follows the river bar below the road. The trail is a natural wildlife trail and corridor. Through Sable Pass we would travel on the road and into Igloo Canyon. This area is a year-round closure for wildlife protection; we made plans to follow the watershed along Igloo Creek and stay overnight at the Igloo ranger station.

Again the day was clear and cold, and I dared not talk about this weather good fortune, so as to not jinx the next day. The day moved slowly at a relaxing pace. A couple of muscles, especially in my jaw, began to unwind.

The next morning, I skied out on the Toklat River Bar, starting off earlier than usual ahead of the sled-dog teams. On the Toklat, I found deep imprints of numerous wolf tracks. I photographed them and made tracks of my own. Again, it was a treat to ski-jour behind the dogs

along the uphill section of the trail, especially Sable Pass. The snow was deeper than in other places along the trail; this had caused a trench to form about knee-deep along the sled-dog trail that was originally cut at the beginning of the year.

Through the peaceful wilderness, I could see as far as Denali. The sun warmed my layered clothes. I stayed up on top of Sable Pass for a long time, resisting the responsibility to travel on.

What lay ahead was another steep downhill. The trail was no more than two feet wide and cut two to three feet deep into snow banked on the side. The grade was angled and curvy. There was no room for error, no room for braking or pole plants. I was the human luge. I sped up quickly in the curves. I went off balance, only to find a side wall bouncing me back to the run. Back and forth, picking up speed on the trail that had been iced by the sled-dog brake shavings and glazed by sunlight. I couldn't imagine going any faster than down Stony Hill—that had been faster than most ski runs in controlled snow conditions. Here I was out of control again, stuck in the ruts of Sable Pass at a high speed.

Snowshoe hare tracks end as a raptor's wing prints leave a tale of predator and prey.

I remember watching the warning "Closed Area" sign go by faster than I ever drove past it in a vehicle. The next curve was steep, and banked into a full switchback. I fell, but was forced back upright by the snow embankment time and again. I didn't slow until the end of Igloo Canyon at Tattler Creek. The run had been rapid: second place to the Stony Hill downhill run. It scored a raving "WAA-HOOO-and-three-quarters!" on the out-of-control enjoyment scale, my enjoy-it-if-you-survive rating system.

Igloo Creek held another glazed-over flow of ice, and I ski-joured through it confidently, building nerve and skill. Gary didn't think I would stay up. If I tried to ski the aufeis solo, I would have surely fallen more than with the sled-dog team pulling me. Legs spread and knees bent, I attacked the canyon with my new skills and had something related to fun—challenge and fear simultaneously coursing through my blood. We arrived at the Igloo ranger cabin as the sun set behind Igloo Mountain.

That night was calm and peaceful. With a waning moon, the night sky returned to darkness. The dogs and wolves communicated on two occasions and the night temperature dropped, colder than the previous nights. I drank the traditional alarm-clock amount of water hoping for northern lights, but to no avail.

At the beginning of the next day we followed the road from Igloo to Sanctuary, then onto the broad Teklanika River. It was the shortest travel day and compared with the previous day's excitement, mostly uneventful. The front country was a day away, eagerly anticipated by Gary for its reunion with his family. For me, I would miss living off of sunrises and sunsets.

From the Sanctuary ranger cabin, the night sky was dark and, to my great excitement, the aurora started early. The strong swirls and patterns were in high contrast to the silhouettes of the Sanctuary Canyon spruce forest. The northern lights were bright and colorful, with pink tones at the north end of the arc that moved toward the east end later in the display.

* ✳ *

The final day started out clear, and by midday was overcast and threatening. We met up with the road near the Savage Campground. The trail paralleled the road either on the shoulder or along some gravel. As we passed mile 10, our view of the mountain disappeared in a building weather cell. We started to see day ski-jourers with one or two dogs on their way to the overlook. We arrived at the park headquarters at 2 p.m., and by 4 p.m. good-byes were complete. I was on the road to Fairbanks for an

Moonlight illuminates the contour of the snow-covered mountaintops. Constellations of stars are abundant.
Here, Orion's belt highlights the ridge line toward the summit. Nowhere else in the world have I seen so many stars as on a winter's night in Denali.

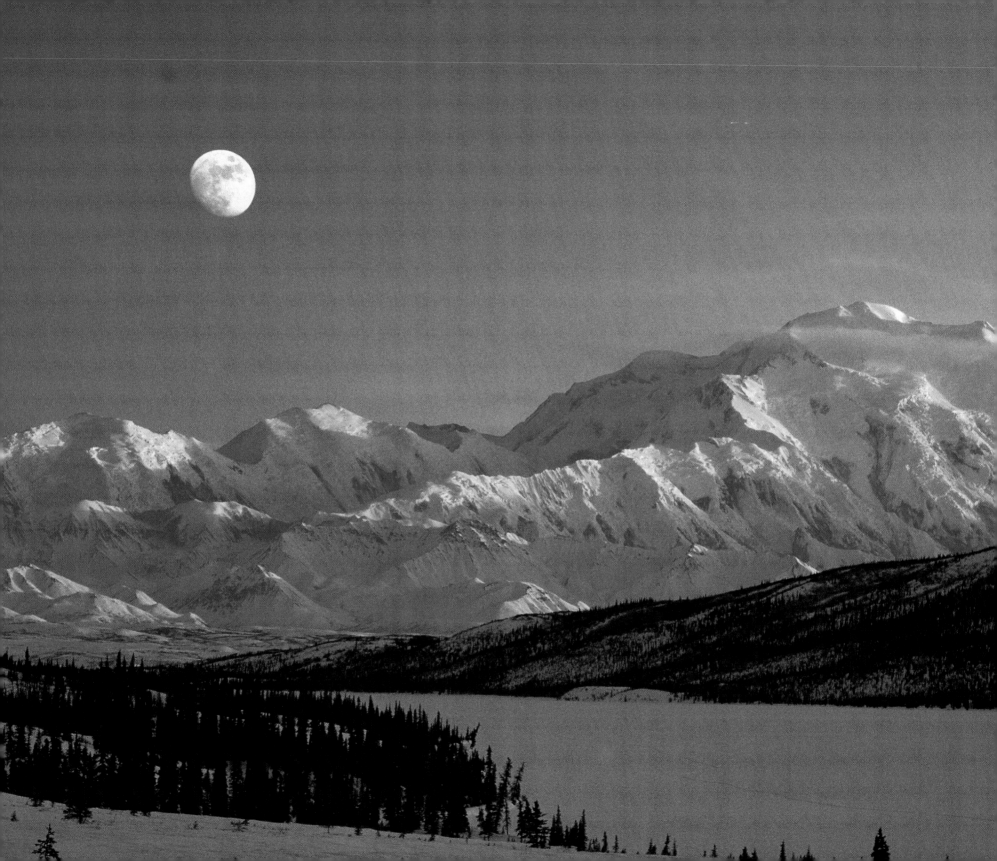

evening marathon of flights to Anchorage, Seattle, and into San Jose by morning. I would have twelve hours in Santa Cruz, then off to Hawaii, Maui, Kauai, and then Midway Atoll for another photo assignment.

The road to Fairbanks was a slippery series of black ice patches. I passed four separate vehicles that had recently skidded off the roadway and were stuck in the ditches. Snow began falling and visibility fell to a minimum. I worried more now about my survival than at any point during the eighteen-day trek through Denali. It was the front country that scared me most—and the immortals who drove the roads too fast under icy conditions with zero visibility. I shook in fright more than I did at the top of Stony Hill, Sable Pass, or Igloo Canyon.

When I saw a truck hit a guard rail and swerve toward me, I accepted a tragedy in the making, but luckily the truck slid to an embankment of high snow on my side of the road. I had been going at a careful pace in the borrowed twelve-year-old Suburban. I stopped and talked with the couple who had been driving the truck. I had made hot coffee and I shared it with them, asking them about conditions ahead in Fairbanks. They said this was the worst spot, mostly because it was downhill for them traveling southbound. I had better traction uphill, but still needed to be careful on the hills outside Fairbanks.

Indeed I survived, giving me more of a chance to consider what we accept as routine and civilized, which requires more survival endurance than backcountry expeditions.

I already longed to be back at Wonder Lake looking up at Denali.

A winter view of Wonder Lake: Denali and a full moon at sunset. Barely visible down the center of Wonder Lake is the winter sled-dog and ski trail.

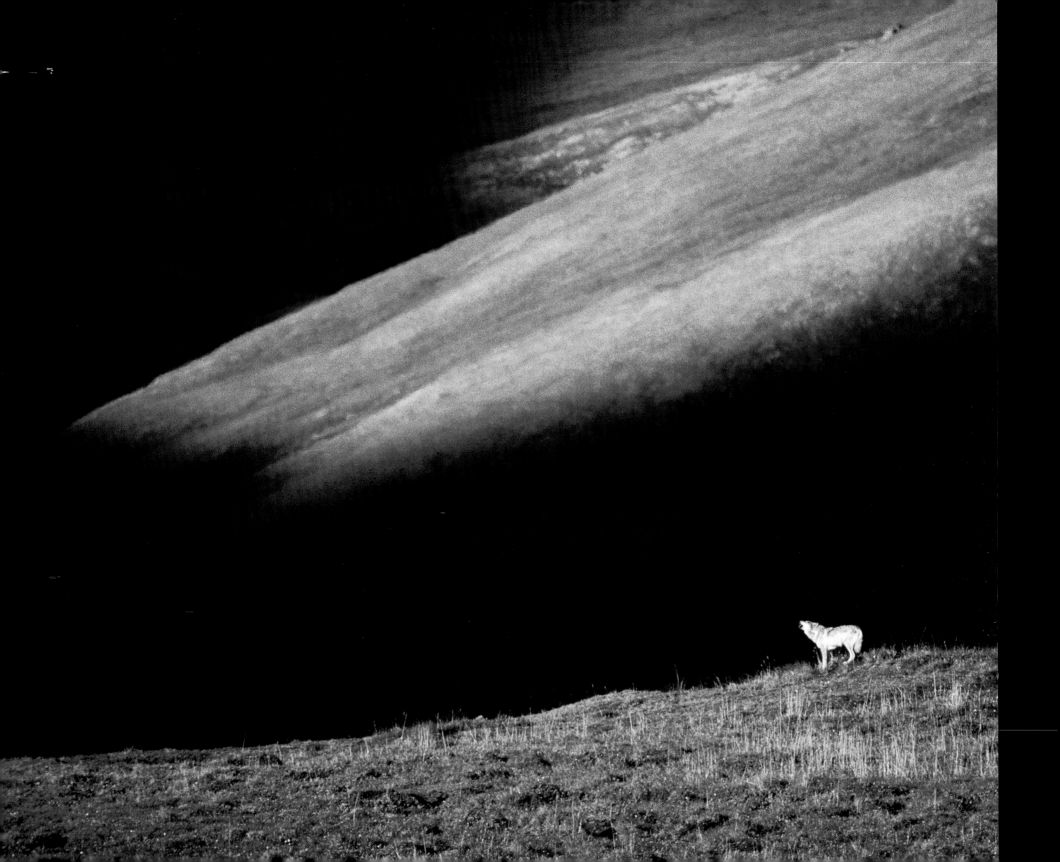

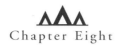

TUNDRA WOLVES AND THE RAINBOW

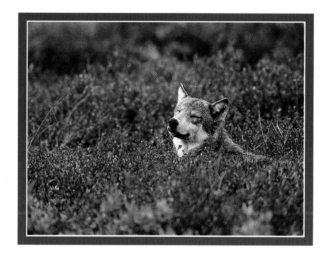

When I hear a wolf howl, I hear the *wild* in wilderness.
Each of the predatory animals has a different expression of this wilderness essence.
Eagles soar, bears have their powerful, grounded presence,
and the elusive wolf is heard more often than seen.

The wolf maintains—and pronounces—its essential wilderness presence with its howl. And on a practical level, it uses it to communicate to other wolves and other animals.

As a young boy at our family fishing cabin, I heard a wolf howl. I remember waking in the middle of the night and asking my parents what the sound was. Nobody in my family had heard it; maybe they were asleep. Then it howled again and another wolf replied in harmony. Still, no one else heard it. For years I thought I was crazy, but as I grew older I found I had a keen sense of hearing. (Notwithstanding that I might be a crazy guy with good hearing.)

LEFT: Highlighted by a break in the clouds, close to midnight, a lone wolf howls to his companion across the valley.

ABOVE: A wolf wakes up from a nap hidden in the tundra grasses.

It wasn't until I camped in the lower Savage River in the summer of 1977 that I heard the familiar sound again. When I heard several wolves in harmony, I again thought of my youth and how scared I was of that same sound. I had been scared of the call of the wild.

Too often when I'm in the wilderness I think of the city, the rushed pace of life, and its endless business. More quickly than anything else, being in the presence of wildlife releases me from these cares. The distraction of a white-crowned sparrow flying from bush to bush or just the watching of ground squirrels chasing each other dissolves the complications of modern life. Hearing the wolf's harmonious howl brings out or reminds us of the wild inherent in all of us—we need to connect with it.

* ❋ *

For years I had experienced only a couple of far-off wolf sightings, hoping that with enough field time I would get a chance at a close-up photograph.

Everybody who was close to Karen and me in the mid-80s asked us why we didn't have photographs of wolves. There were many published photos of wolf close-ups, playing or looking like tryouts for a pedigree dog show. The truth was, many of these photographs were of captives, wolves in fenced enclosures. Movies use trained animals, and unbeknown to many, so do some still photographers.

There is a distinct difference in a chance encounter with wildlife, and it is something that not everyone has the opportunity to experience. If you want to see a wolf in a captive setting, you can see one for the price of an entrance ticket. To experience a wild wolf, you can search wild places for years before coming across a track. There is a deeper, more meaningful experience in a wild wolf encounter. A chance encounter is something to savor and something for which to be grateful.

Karen and I have had the good fortune of many great wild-wolf sightings and photographic opportunities: in the Arctic National Wildlife Refuge, the Brooks Range, the Alaska Peninsula, and other remote locations, but not for a long time when we first started in Denali.

In Denali, we would occasionally glimpse a wolf or have a brief, limited photographic opportunity, but nothing compared to the sightings of other large animals. Usually, the rare opportunities to view wolves were associated with them hunting ground squirrels. One windy day, a ground squirrel I was photographing repeatedly stood upright on its back paws in a patch of autumn fireweed. As I worked this squirrel, I found it surveyed to its left as often as it looked at me. As I checked the direction the squirrel had been watching, a wolf appeared. The wolf was watching the ground squirrel from twenty-five feet away.

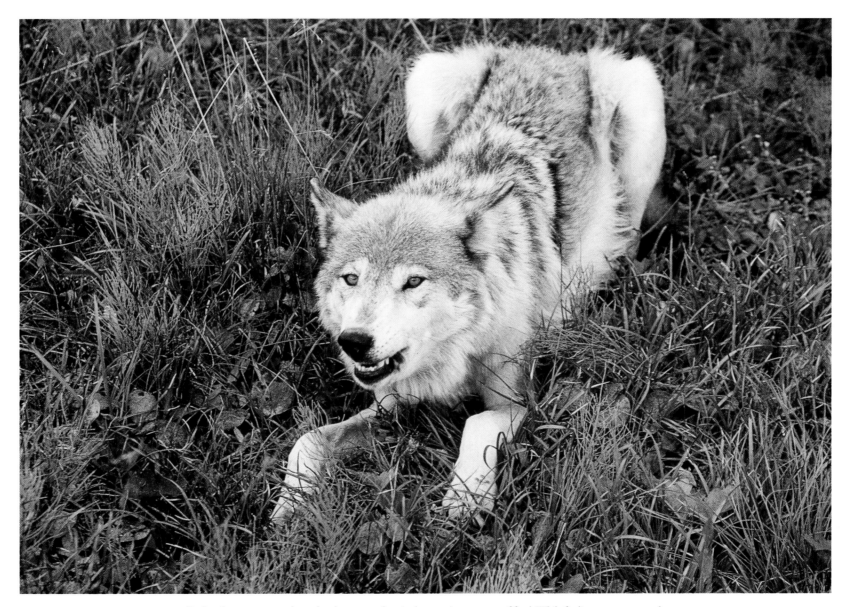

During the summer months, wolves hunt ground squirrels as a primary source of food. While feeding on a recent catch,
this wolf hears another squirrel nearby and crouches in a stalking position planning its next hunt.

One hundred forty-nine

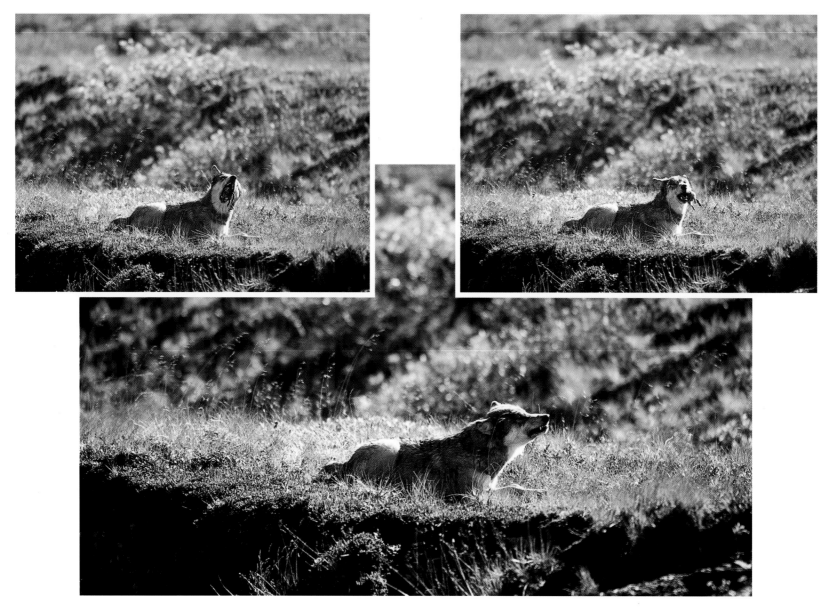

After the capture of a ground squirrel this wolf systematically chews his meal in a rotating manner adding saliva to moisten the swallowing.
Single wolves feed on squirrels, hares, and small birds while packs typically hunt larger prey.

One hundred fifty

I focused my lens on the wolf, which had ignored me until it heard my camera. Then with a jump, a hop, and a pounce, the wolf caught lunch.

Predator/prey relationships are labeled with phrases such as "survival of the fittest," "dog-eat-dog," and other metaphors. In Denali, the nickname for ground squirrels is "tundra hamburger." Golden eagles, ravens, gyrfalcons, jaegers, magpies, mew gulls, and owls are just a few of the birds that feed on ground squirrels. In addition, larger animals, including bears, fox, lynx, wolves, and wolverines dine on tundra hamburgers. And consider this: I have watched ground squirrels feed on other road-killed squirrels.

Wolves and other animals use the park road as a travel corridor year-round. The road transects the major river and mountain-pass corridors, which are an incredible wildlife habitat. Ground squirrels seem more plentiful along the gravel road than in other places. From my observation of habitat on and off the road, ground squirrels seem to prefer the disturbed gravel along the flanks of the road, in which they easily build underground dens. The increased squirrel populations might be a factor as to why wolves and other predators patrol the road. This road corridor is not without its risks as well as its rewards, however. This food source means you may see wolves there; road kills are free lunches for the predators as they travel the road.

Karen and I followed a wolf one night as it picked up ground-squirrel road kills for many miles. The wolf even ate the really flattened ones, days old. The wolf moved at an even-paced trot, about 10 miles per hour, stopping to occasionally smell or look around. When it came across a road kill, it devoured it and immediately patrolled on down the road. Obviously, this was an established routine. It also hunted for live squirrels, successfully killing one as we watched. After this observation, we found many more examples of successful roadside hunting by wolves.

Wild wolves are champions; we all need to be reminded of the freedom they embody.

* ✳ *

Charlie Ott had worked as a heavy-equipment operator in the park for many years. He is a noteworthy photographer. After he retired from roadwork, we would see him in the park, a professional photographer on permit. He often joked about seeing wolverines, lynx, or wolves. Charlie had white hair and a white beard—a shoo-in for Santa Claus, if you had the nerve to ask him to dress up.

In 1994, Charlie saw us in the park, and as we chatted he revealed that he had always dreamed of getting a Denali wolf photo. Karen and I replied that we were on our way down by Wolf Creek to wait for the wolves that were in the area. Charlie didn't quite believe us, but followed out of curiosity. He stopped at Wolf Creek with us, doubting our every move; I think he expected some kind of trick or set-up.

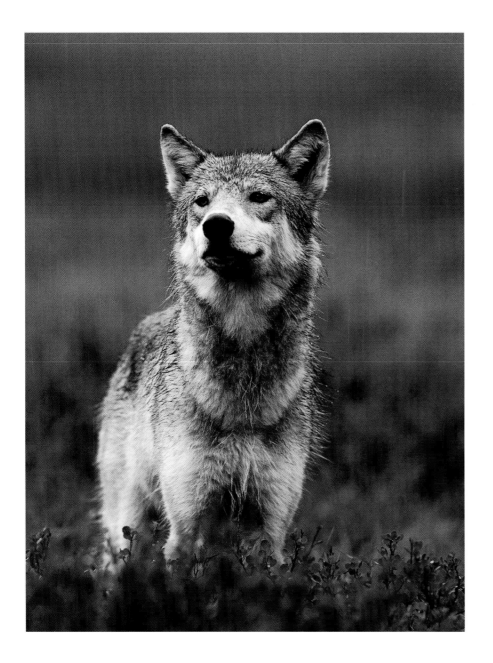

After an hour, *bingo,* a wolf. Charlie just stared at us until Karen told him to get his camera. We laughed at his demeanor: scratching his beard and looking at the wolf closing in and then back at us. The wolf came close by, hunted successfully, and patrolled again. We shot photographs in good light, changed rolls, and then shot again. The wolf crossed the road, continued hunting, and disappeared. When it reappeared, it was trotting off a mile away.

Charlie collected his thoughts, came over to me, and hugged me. He said, "I never thought I would get a Denali wolf photo."

I joked with him, replying, "I never thought I'd be hugging you. Go hug Karen." Laughing, I realized that for both Karen and me there is a great satisfaction and camaraderie in sharing wildlife experiences, especially with those who truly appreciate it.

* ✳ *

In 1996, a pair of wolves hunted the Stony Hill area regularly as their prime habitat. It was a good year for ground squirrels in the area. To our knowledge, for

Rain saturates the outer fur of this beautiful wolf we called Rainbow—seen once beneath the colorful arc. Long, outer guard hairs of the fur act as a raincoat for the wolf.

the first time, a wolf sighting was almost consistently assured, for close to a month. A day or two would sometimes go without a sighting, but the next day a wolf returned to patrolling the area.

One day, Rita, one of the Eielson-Toklat area park employees, was intent on seeing the wolf and wandered by us on the road. The day was drizzly and partly cloudy. There was a brief rain squall, and a rainbow shone brightly through a window in the clouds. Rita, Karen, and I found a wolf beneath the rainbow. From the combination of events, we named the wolf Rainbow as a symbol of reward and hope.

Rita is a champion in her own battle with breast cancer. She was forced to give up working in Denali the next year to fight her battle with cancer. With the courage of the wolf (and the hope from the rainbow), she bravely challenged life, and survived. The strength and courage gathered from her wilderness experience mixed with the hope of returning to Denali, which came true in 1998 when she returned to work at Eielson Visitor Center.

The power of wilderness and wildlife can heal the body, mind, and soul if you allow it.

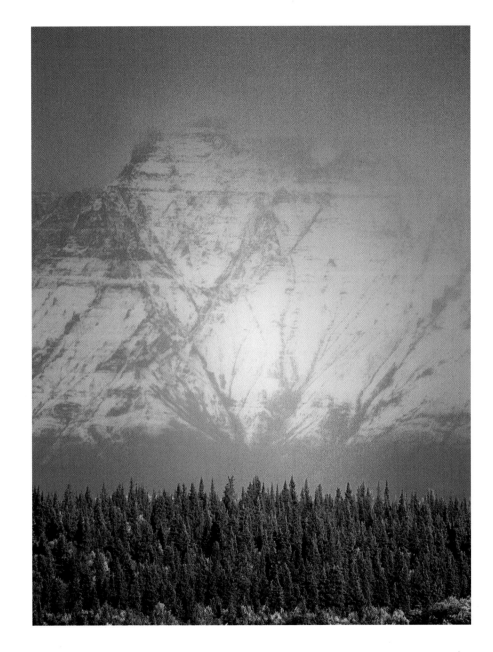

Snow, ice, and rain form a broad band of color in a faint rainbow.

* ✹ *

The pair of wolves that frequented Stony Hill were so alike in appearance that only their tail markings were different. One night around midnight, when the sky did not completely darken, we found Rainbow at the east base of Stony Hill. A dark cloud came from the northeast, and in no time lightning and thunder began. We had never seen a thunderstorm in Alaska. We became concerned—hail, lightning bolts, and thunder closed in. The open, treeless country lent no shelter.

The wolf crossed the road in front of the storm and hunted close by us. We were ready to photograph, but the light was minimal. When the first thunder sounded against the hills, a second wolf howled from across the valley. Rainbow returned the call with a slower, steady-pitched howl. The second wolf whimpered, howled, and cried. The contrast in howls was obvious when listening to them side by side.

Clouds, thunder, lightning, and now hail reached the ground. Karen and I listened to the thunder rumble and the wolves howl, and felt fear at Stony Hill at midnight. Between thunderous rumbles and lightning bolts, the wolves howled and communicated. Soon the second wolf gradually came closer and found Rainbow. They rolled and mouthed each other as we tried to take photographs under darkened skies. We followed them up and over Stony Hill, as they retreated from the storm.

Our hearts stopped when lightning struck close to us, and close as well to the pair of traveling wolves. They cried out in a fearful howling harmony. The wolves ran, and Karen and I followed. We moved over Stony Pass to the creek west of Stony Hill, where the midnight sun shone through, causing an alpenglow-colored rainbow opposite the two wolves: Rainbow and Double Rainbow. It was one of the most magical moments we had experienced in nature and in Denali.

For us it was a much better story than a picture. Moments like these are why I began writing; it hasn't been enough to tell the story in pictures alone. Writing can add the lost details and blend in a different perspective of mood and impact. Images cannot always be photographically documented in their fullest sense.

That midnight on Stony Hill was a juxtaposition of an amazing natural history event. The storm brought together an immutable experience of the awesome wilderness: the sharing of fear and joy alongside two wolves at a meaningful juncture in time. It was a crystal, natural moment in Denali—for me, in the last true wilderness.

Karen and I found this sunrise along the Teklanika River electrifying—
its many sizzling shades of red greeting the dawn of another champion day in Denali.

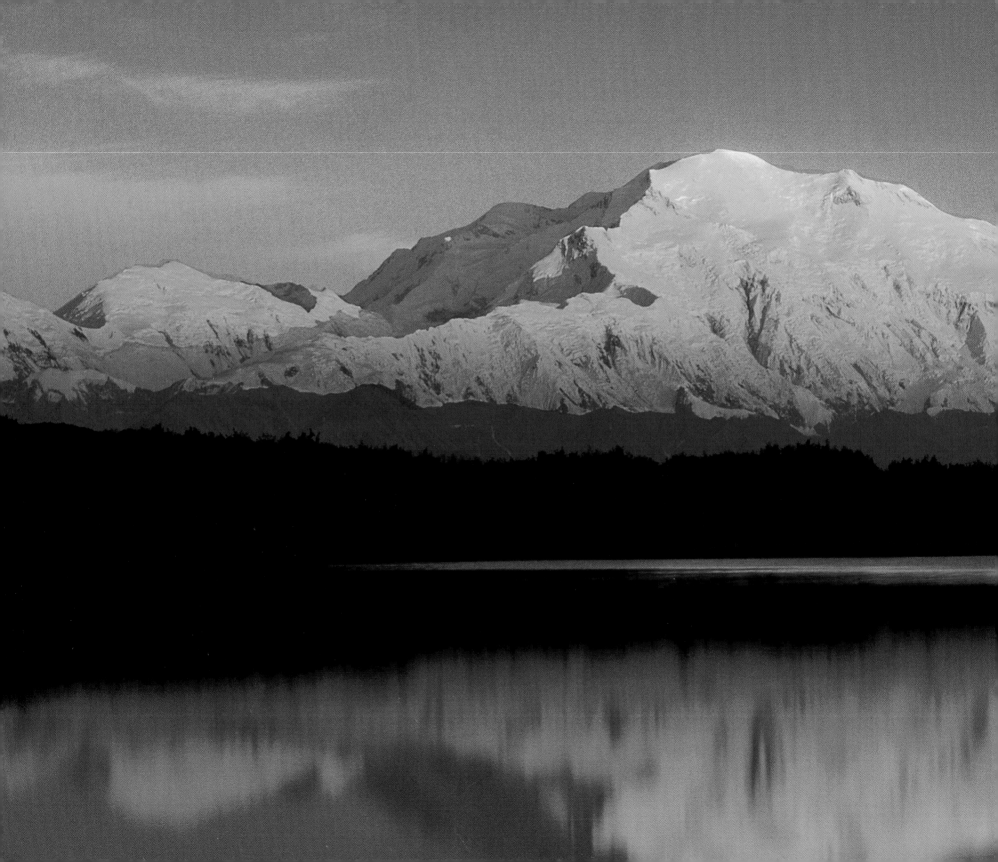

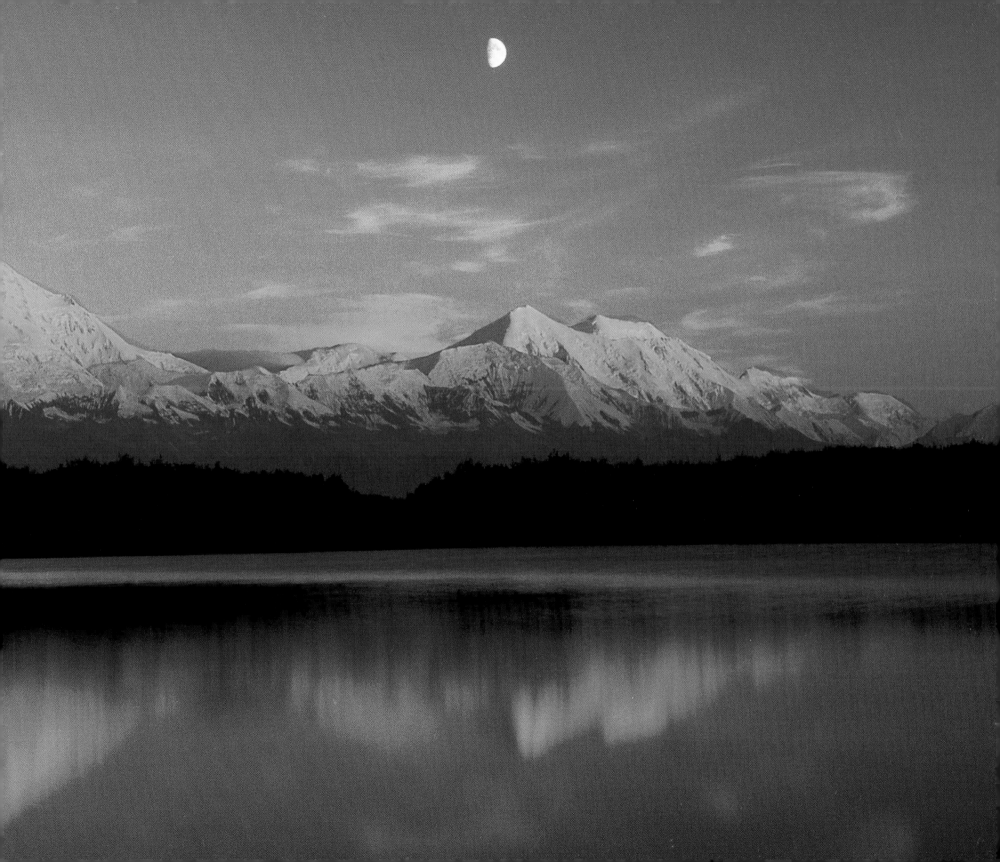

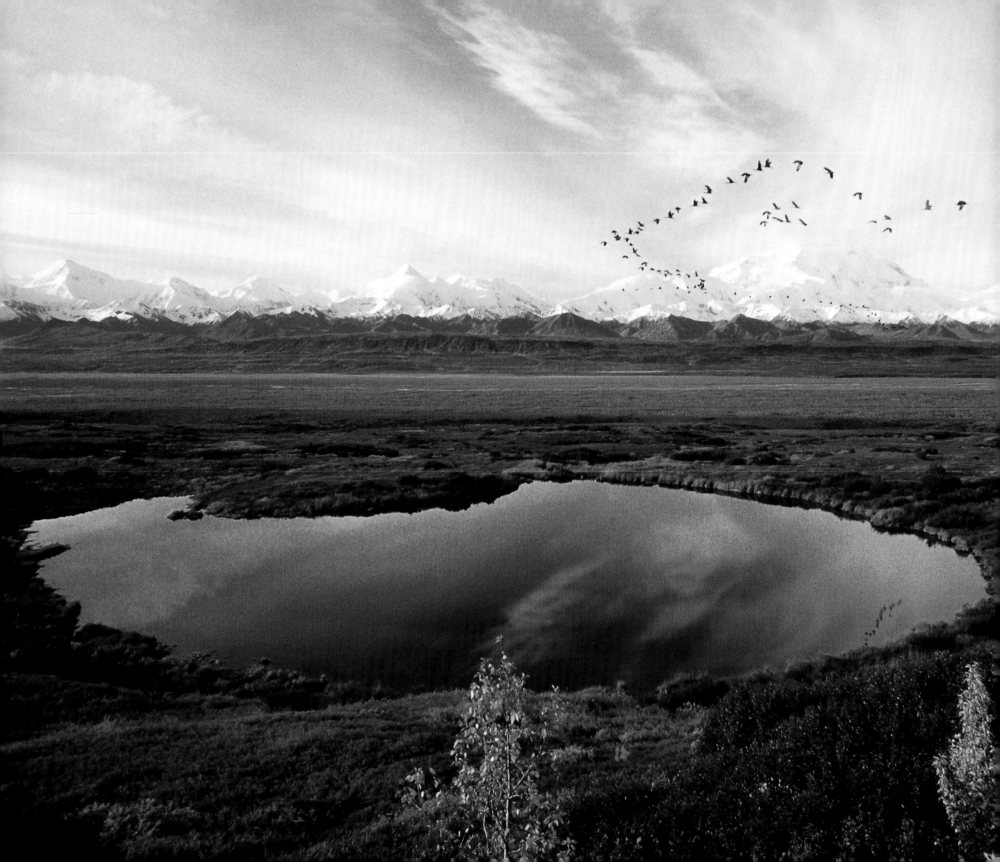

REFLECTIONS OF DENALI

Today as I write this, it is an autumn day and I am looking out over the kettle ponds
in the foreground with Denali, the Great One, rising in the distance.

Snow covers Eielson, Highway, Sable, and Stony passes. A wolf howls in the distance, the golden aspen alongside the road quake in the wind, and the taste of a blueberry picked just a moment ago lingers on my taste buds. The colors of the tundra are still primarily red fading to maroon across the landscape. In three groups of over a hundred, sandhill cranes call out as they pass overhead.

The mountain glistens from the new snow, reaching down to 3,000 feet. The smell of autumn fills the air. A bull moose in the kettle pond splashes, his antlers shedding water as he feeds on aquatic plants. Upstream a beaver slaps his tail, annoyed at the moose that is disturbing the pond. The chill in the air brings me a reflective moment about the advancing change of season. I reach down to pick a handful of berries to share with Karen as a ground squirrel chirps.

LEFT: A large group of sandhill cranes fly over a kettle pond in front of Denali along the Alaska Range.
Thousands of sandhill cranes migrate through the park heralding the peak of autumn and the coming of winter.

ABOVE: A fallen spruce tree is decorated in the autumn foliage.

Off in the distance we see a Toklat-colored animal moving across the tundra. I begin telling Karen my favorite story.

Adolph and Olaus Murie, two of the most recognized contributors to the understanding of wildlife behavior in Alaska, were out for a hike. It was about midday and Olaus told Adolph a true story about a day he watched a bear out on the tundra. Then, Olaus was getting hungry, so he sat down to have lunch and watch the bear. As the Toklat grizzly ambled toward him, he noticed how big the beast was, and that it was so enlarged that it had to waddle. After he finished lunch he checked out the bear with binoculars and began to laugh. The perspective of the open rolling tundra can be confusing regarding distance and size. That Toklat-colored creature was none other than a porcupine.

Karen and I laughed as we carefully scrutinized the form out on the tundra.

In the tradition of all our champions, we experience the park. For half of my life, I have been involved with Denali. It is more than the sum of its champions, the accumulation of years of experiences and adventures, the abundant flora and fauna, or the tallest mountain in North America. It is all of this and more than words can express. It has been the greatest place we have had the fortune to learn about and experience, an unsurpassed place of living wilderness essence.

We eagerly look forward to the opportunity for more adventures in the shadow of the Great One, Denali.

ᴧᴧᴧᴧ

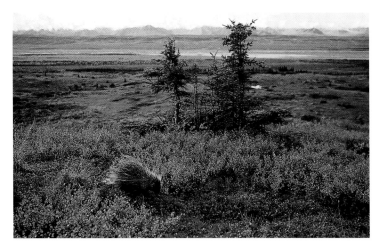

Our "bear" was a porcupine, too.